IMAGES
of America

THE CALIFORNIA
DELTA

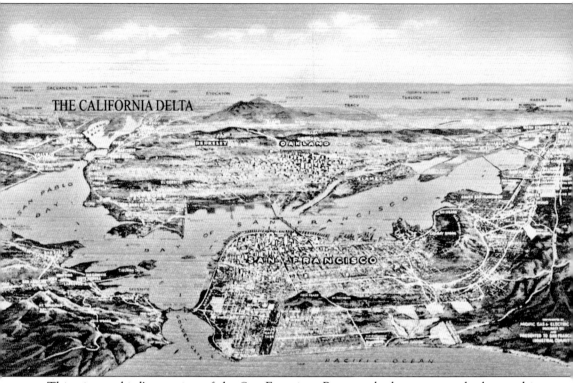

THE CALIFORNIA DELTA

This vintage bird's-eye view of the San Francisco Bay area looks east over the bay and its meandering San Joaquin and Sacramento River delta. The California Delta's rivers, sloughs, and islands encompass over 6,000 square miles of land between Courtland to the north, Stockton to the east, and Suisun the west. (Photograph courtesy of the author's personal collection.)

ON THE COVER: A bevy of queen candidates poses in this promotional image for the annual Rio Vista Bass Derby and Water Carnival in 1935. The contestants vied for queen by selling tickets to the event. Every girl won in this swimsuit competition! The fishing was great, as evidenced by the large stripped bass, the beautiful day, and the welcoming Sycamore Park launch. (Photograph courtesy of the Rio Vista Museum.)

IMAGES
of America

THE CALIFORNIA DELTA

Carol A. Jensen
Hal Schell Archives
East Contra Costa Historical Society

ARCADIA
PUBLISHING

Published by Arcadia Publishing
Charleston SC, Chicago IL, Portsmouth NH, San Francisco CA

Printed in the United States of America

Library of Congress Catalog Card Number: 2007924637

For all general information contact Arcadia Publishing at:
Telephone 843-853-2070
Fax 843-853-0044
E-mail sales@arcadiapublishing.com
For customer service and orders:
Toll-Free 1-888-313-2665

Visit us on the Internet at www.arcadiapublishing.com

*For Hal and Joanie Schell and their many friends
along the 1,000-mile delta waterways*

CONTENTS

PROLOGUE

This book is really Hal "Mr. Delta" Schell's last book. He began this effort in 2003, but fell ill and passed away before its completion. I hope his spirit is captured correctly. Any errors and omissions in the writing are all mine.

My great appreciation is extended to the family and loved ones of Hal Schell for granting access to his archive. Hal's stepdaughter, Kathy Lipelt, has been most gracious. Many anecdotes about Hal and his life in the California Delta were contributed from sources too numerous to list. I am also indebted to the following organizations and their volunteer staff members: the Rio Vista Museum, the Isleton Museum, the Bank of Stockton, and the Rio Vista Dredging Museum. Philip Pezzeglia, curator of the outstanding Rio Vista Museum, was invaluable in providing access to archives and reviewing text. Janet Bennett, guide for the Dutra Museum of Dredging, provided insights into land reclamation and dredging. Ed Concepcion, curator of the Isleton Museum, provided valued information on agriculture, canneries, and Asian pioneers. Thanks go to William Maxwell, archives manager of the Bank of Stockton, Covello Collection, for contributing images. Photographs were also provided from the collections of Garth G. Groff, Kenneth C. Jenkins, and Wilbur C. Whittaker, members of the Sacramento Belt Line Railway. Members of the San Francisco Bay Postcard Club (www.postcard.org) have been most generous in providing access to their personal collections. My gratitude is extended particularly to club members Lew Baer of Petaluma, Edmund Clausen of Oakland, Darleen Thorne of Cupertino, and Jack Hudson of Dublin. All images in this volume have been provided by the donors listed above and by the archives of Hal Schell.

Thank you to John Poultney, the Arcadia Publishing editor who convinced me to step into Hal Schell's shoes, and to junior publisher Devon Weston for fulfilling the editor's role on this publication. The aid and patience of the irreplaceable Robert D. Haines Jr. cannot be overstated. Dr. Robert Chandler, historian, supports and encourages my attempts. And writing is impossible without the excellent and thorough copy editor extraordinaire Marcy Protteau.

Thanks to all for sharing local histories. Please e-mail the author at Historian@ByronHotSprings.com if you can contribute to the history of the California Delta. The wildlife, agriculture, and water deserve our protection, as do the lifestyle, good times, and recreational opportunities the delta provides. Do your part to save this wonderful resource.

—Carol A. Jensen

ACKNOWLEDGMENTS

My last book, *Cruising California's Delta*, now out of print, contained quite a lot of delta history, especially about steamboats. I was lucky to have help from many experts, and the knowledge gained from them has helped me with this book. Foremost among those who assisted with the last book were Horace Spencer, Richard E. Brown, Bill Stritzel, and Jack Ogglesby. Others who shared knowledge and material on this new book include Moyne Martinez, George F. Schneider, Tom Herzog of the Sacramento Delta Historical Society, author Kathy Leighton of Byron, Mary Phiepo, David Phiepo, Roberta Fuss, William Shelton, David Breninger, Barry Wysling, Dan Schueler, Steven J. Pickens, Garth G. Groff, delta artist Marty Stanley, Ni Orsi, Anita Troglia, author Olive Davis, historian Leslie Crow, Sonja Hansler, historian Kathie Hammer, and Dave Thomson, who runs a Web site dedicated to Mark Twain and steamboating. Members of some of the older delta yacht clubs were kind enough to dig into their archives and gather material from members of long tenure. To them I am grateful, even though, because of space limitations, we could not incorporate material from every club in the delta.

Geographically, this book covers a sizeable chunk of territory. Logistically, gathering and reviewing photographs was not always easy, and in most cases, we did not want to entrust them to Uncle Sam's mail. Some of us learned about high-resolution scanning, and we moved photographs back and forth via e-mail. We have not been able to utilize every photograph offered. Some were of subjects we already had covered, some were not up to the quality level required, and some we did not have room for. In the end, it turned out to be a culling process.

I simply cannot do justice to all of you who offered to help. Nevertheless, I am indeed grateful. I am grateful also to my wife, Joanie, who shares the garret with me and has grown used to seeing my projects scattered throughout our humble abode. Both of us live with these projects daily.

—Hal Schell

INTRODUCTION

We all need to drive up to the top of Mount Diablo someday —or hike up, or, even better, gallop up on horseback. Once there, we could squint our eyes, peer off to the east, and see what the Spanish explorers and clergy saw on March 30, 1772. With the delta swollen by spring rains and runoff, it looked very much like what they thought they were seeing: a large inland lake.

Explorers and others came later: Gabrial Moraga in 1805, mountain man Jedediah Smith in 1827, and French trappers from the Hudson Bay Company in 1829. By 1837, John Marsh had built his adobe at Los Meganos and established Marsh's Landing for water transport and commercial shipment. In 1839, John Augustus Sutter sailed up the Sacramento River in two small ships and founded New Helvetia. In this guise, our state capitol, Sacramento, got its start. Capt. Charles Weber sailed the sloop *Maria* up the San Joaquin River in 1848 and founded Stockton.

On January 24, 1848, James Marshall, while toiling on a sawmill at Coloma for John Sutter, saw some flecks of yellow in the millrace. Sure enough, it was gold. This was not an easy secret to keep, and in a short time, the whole world knew about the discovery of gold in California. Then began the craziness called the Gold Rush. The rest, as they say, is history.

There is always the tendency to describe the California Delta (officially, the Sacramento–San Joaquin Delta) in terms of its geographic and economic attributes. One thousand miles of navigable waterways, say the chambers of commerce. Fed by five major rivers and lesser streams and sloughs, mumble those who try to get a handle on this elusive place. Deepwater ports visited by vessels from around the world, say the economists. Incredibly rich farming soil on over 55 major reclaimed islands, totaling over 500,000 acres, say those with an agricultural bent. Pretty good fishing and outstanding duck hunting, say the sportsmen. Good birding, say the bird-watchers. One of the 10 best sailboarding spots in the world, say the sailboarders. A source of drinking water for nearly 70 percent of the population of California, say the water barons.

But true delta people have different ways of explaining their love for the delta and what it is that is so unique about this great place. They speak of the River Route mail carrier, who delivers mail six days a week over a 65-mile water route; rain, tule fog, heavy wind, and whitecaps on the water will not stop him. Or of hotel magnate Barron Hilton's decades-long Independence Day tradition of staging an "ooh-ah" fireworks display for some 25,000 boaters anchored in 6,000 boats of every size and description.

The delta river towns, some not much changed in 120 years, stage their traditional festivals. In the hamlet of Courtland, it is the Bartlett pear they worship; in Isleton, the crawdad; in Rio Vista, the striped bass; in Pittsburg, seafood; and in Stockton, asparagus. In Old Sacramento, they get all worked up over Dixieland jazz, and in Bethel Island, over 1950s-era automobiles. Eight or ten yacht clubs are involved in staging beautiful lighted-boat Christmas parades. Somehow, out here in this place of tractors and crop dusters, of sandhill cranes and coots, of ultralight seaplanes and noisy personal watercraft, the denizens of the delta manage to coexist amiably enough. (Well, no one appreciates the boat wakes very much.)

There is a sort of vernacular of the river here. Even non-boaters begin to speak in nautical terms. A delta roadway becomes an asphalt slough. The front of a vehicle, whether it is a boat, a tractor, or an 18-wheeler, becomes the bow, and the opposite end, the stern. A saloon is a watering hole. Even when we go to a shoreside gas station, we are taking on fuel. Here on the river, we merely call this great place the delta.

—Hal Schell

Harold F. "Hal" Schell was born on August 20, 1929, and died on June 9, 2006. Hal Schell wrote about the California Delta for some four decades. His delta works include five books and a few thousand articles and columns. His monthly column, "Dawdling on the Delta," appeared in the *Bay and Delta Yachtsman* magazine since 1972. Schell built the Delta Chambers Web site and ran it for over six years. His monthly e-mail newsletter, "California Delta Scuttlebutt," has over 8,000 subscribers. Schell rode at 65 miles per hour in one of Howard Arneson's boats, rode a water buffalo as grand marshal of the Rio Vista Bass Festival parade, and had a great view as grand marshal of an early Isleton Crawdad Festival parade. He blew reveille on his bugle at 8:00 a.m. during boat raft-ups many hundreds of times. He ate shark at Union Point Resort and sipped mai tais at Lost Isle. Schell was pelted by hailstorms and experienced the wrath of a "peat-dirt" rain. He fell overboard all by himself in the dark of cold January nights. He had a heck of a lot of fun in this place we all love so much: the California Delta.

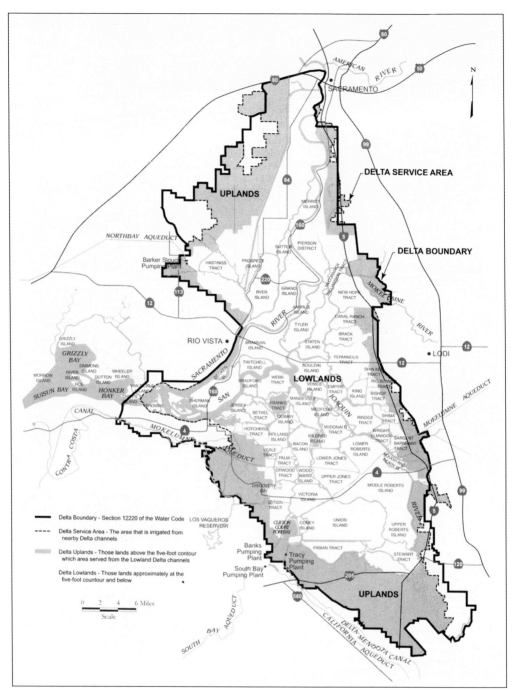

The California Delta consists of the famed 1,000 miles of recreational waterways and much more. The area encompasses over 6,000 square miles of land, running 100 miles north to south and over 60 miles west to east. It includes over 70 reclaimed islands, fertile agricultural lands, and the heart of the state water system. More than 500,000 people live in this area, which is now one of the fastest-growing suburban areas of the state.

One

PADDLE-WHEELER ERA

The California Delta's heyday of paddle-wheel steamboats is associated with the Gold Rush, but what was probably the first paddle steamer to dip its hull into the fresh waters of the delta, the 37-foot side-wheeler *Sitka*, arrived in 1847, a year before the Gold Rush began. *Sitka* was brought from Alaska in pieces aboard the Russian bark *Naslednich* and was reassembled in Yerba Buena (now San Francisco). On November 29, 1847, it headed up the Sacramento River to John Sutter's New Helvetia (now Sacramento). The petite steamer took just over six days to complete the trip, and the wags of that time claimed that on *Sitka's* return voyage, a team of oxen made better time than it did from New Helvetia to Benicia.

Most of the delta's early paddle wheelers were built on the eastern coast of the United States and got here by going around the horn. It was a grand occasion in October 1849 when the 226-foot side-wheeler *Senator* arrived after a seven-month journey from her home port in New York. For more than 30 years, she was a regular on the San Francisco–Sacramento run. Later in 1849, Captain Warren introduced Stocktonians to steamboat travel when he arrived with the side-wheeler *John A. Sutter*. It is said that within a few months the captain had earned himself a net profit of some $300,000.

At that time, most of the big steamers required deeper water. Among these were the ships *Senator*, *Yosemite*, and *New World* (which was brought around the horn by Capt. Ned Wakeman, with the sheriff in pursuit). By the time the Transcontinental Railroad was feeding Easterners into Sacramento and San Francisco, the upper rivers had silted up with the tailings created by placer mining. The big side-wheelers were placed into service in deeper water closer to the San Francisco Bay. They were replaced by shallow-draft stern-wheelers and by paddle wheelers built in San Francisco, Stockton, and Broderick (now West Sacramento).

The delta's paddle-wheeler era lasted just over 90 years. During that time, it is estimated that over 300 paddle steamers thrashed through the waters of the greater delta. Other paddle wheelers have entered into excursion service since then, including one or two that were steam driven. It was quite a time—one worth remembering by those lucky enough to be able to.

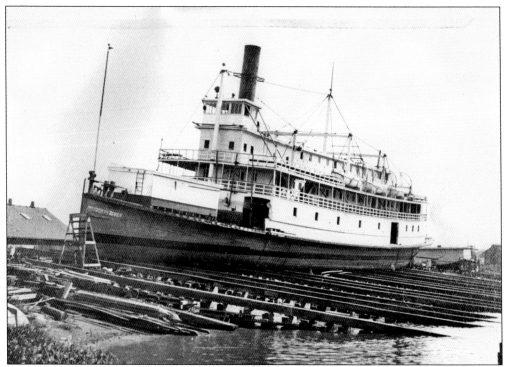

Pictured is the 175-foot stern-wheeler *Pride of the River* on the Central Transportation Company's dockyard ways prior to being launched in Stockton. Built in July 1878, she was sold to the U.S. Army in 1942 and sank in China Basin, San Francisco, on March 14, 1952. She cost $60,000 to build and sailed under the command of Captain Terscheren.

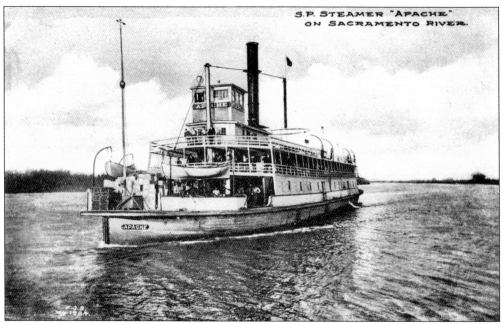

The Southern Pacific steamer *Apache* is pictured here on the Sacramento River around 1910.

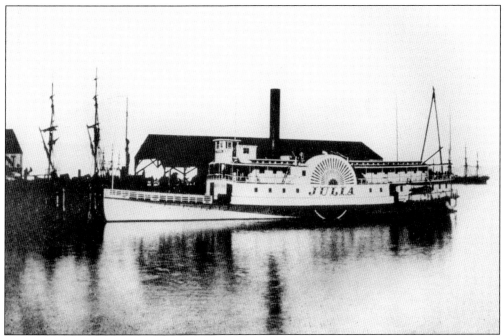

The 170-foot side-wheeler *Julia*, built in 1870, was perhaps the first to use oil for fuel. On February 27, 1888, she caught fire at the south Vallejo wharf. The conflagration took 600 feet of wharf and killed 30 passengers. It took a long time after the fire for river boaters to feel comfortable using oil for fuel.

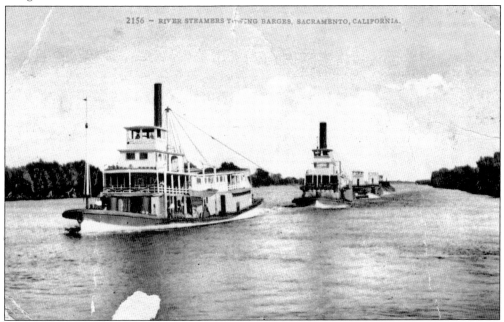

This color postcard, postmarked in Vorden on May 23, 1910, shows the *San Joaquin* and her sister ferry towing barges on the Sacramento River. The card is addressed to a family member and is signed by Ilsie Leffler. It reads, "Dear Ennet. How ear [sic] you and grandpas. Ilsie went [sic] you to come up Saturday to her birthday."

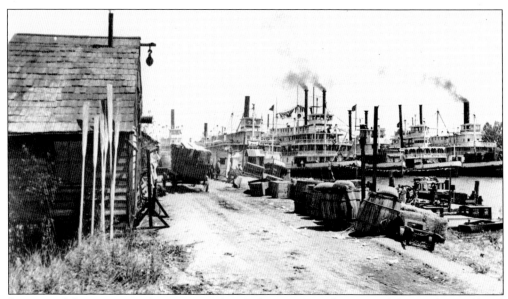

Portions of the great steamboat race in the 1935 movie *Steamboat Round the Bend* were filmed off Buckley Cove in Stockton. Here the steamers *Leader*, *Port of Stockton* (formerly *Capital City*), *Cherokee*, and *Pride of the River* line up for the event. This was Will Rogers' last movie; in August 1935, he died in a plane crash in Alaska with friend Wiley Post.

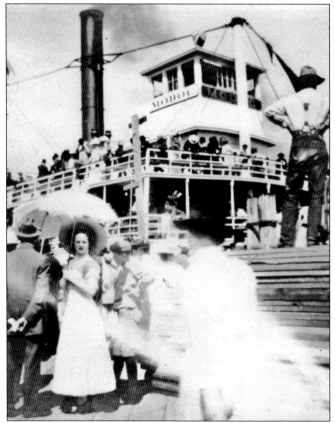

This image of the stern-wheeler *Modoc* taking on passengers looks like something out of a Hollywood movie, but it shows true life as it was lived in California around 1900. The ship was built and operated by the Southern Pacific in 1880. It weighed 929 tons and was 207 feet long.

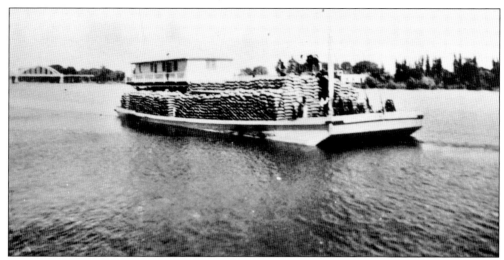

A river scow (above) transports grain on the Sacramento River. A scow is a flat-bottomed boat with square ends used mainly for transportation of bulk agricultural goods. Shallow-draft scows could reach into narrow and shallow backwaters to bring produce out to the main river. Once a large shipment arrived at main channel destinations such as Locke, Walnut Grove, or Rio Vista, the produce could be stored in granaries or warehouses while awaiting larger ships. Produce could also be stored to avoid flooding the market and deflating prices. Cargo was transshipped on larger steamers working the main channel, such as this stern-wheeler "potato barge" (below), which is loaded with sacks of potatoes or onions going to market.

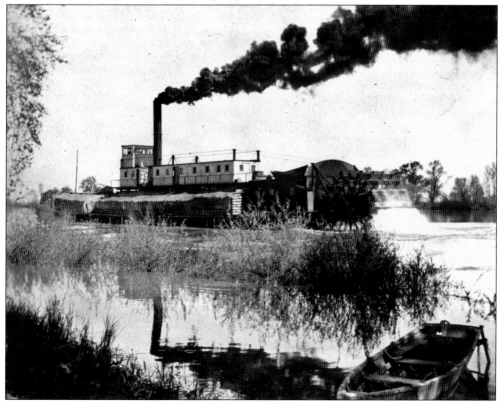

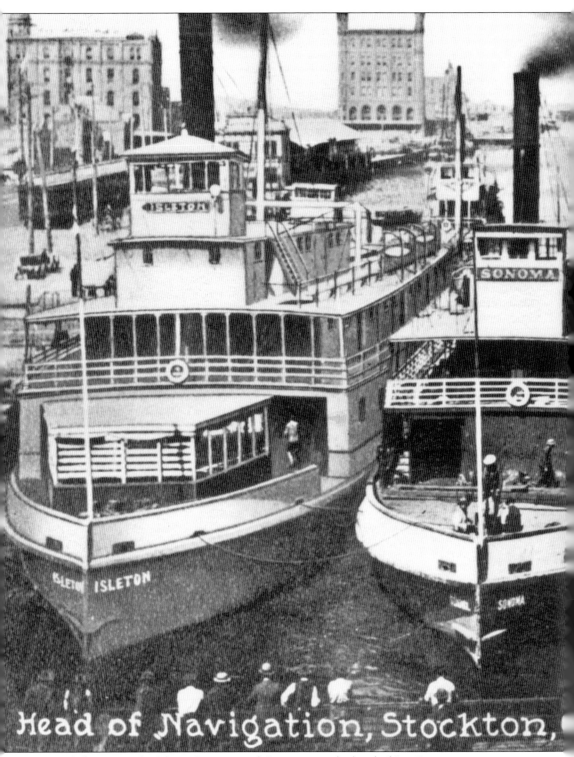

Head of Navigation, Stockton,

Tied abreast are the *Isleton*, *Sonoma*, and *Constance* at the head of San Joaquin river navigation at Stockton. The *Isleton* was rebuilt as a motor vessel and converted from steam to diesel power

ifornia.

2107

CONSTANCE

and from paddle wheel to twin screw in the 1930s. The U.S. government purchased the *Isleton* in 1942 and renamed her the *Army Queen*.

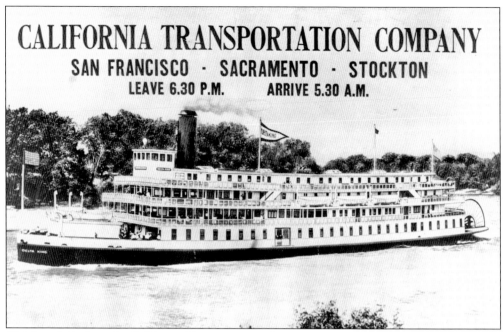

This broadside from the California Transportation Company promotes the *Delta King*. From 1927 to 1940, this ship provided daily transportation of passengers and their automobiles to Sacramento from San Francisco. Advertisements such as these are highly prized by collectors because they document early California shipping.

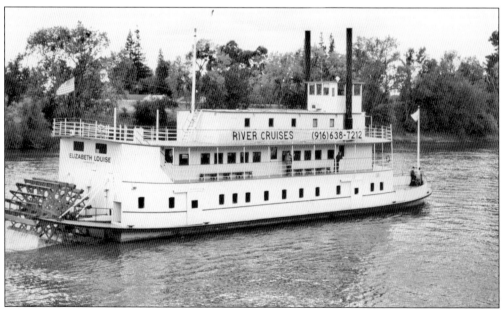

The excursion boat *Elizabeth Louise* was an important part of the Sacramento Yacht Club's opening-day parade of ships. Sadly, she was last seen was going downriver under tow.

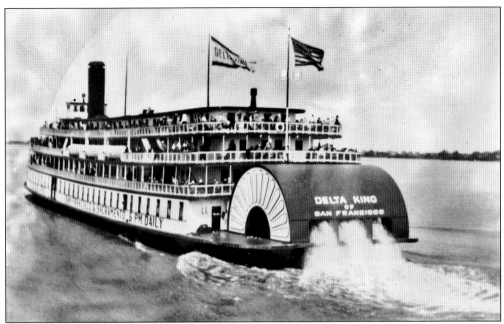

The 285-foot stern-wheeler *Delta King* (above) was launched in Stockton in May 1927 and could accommodate 468 passengers. It made runs between Sacramento and San Francisco with its sister steamer, *Delta Queen* (below). On July 26, 1984, Walt Harvey and Ed Coyne towed the derelict *Delta King* to Sacramento. After much restoration, it was opened on the Old Sacramento Wharf on April 28, 1989, as a deluxe floating inn and bistro. It still serves the public in that capacity today. The *Delta Queen* has continued her active passenger life. After years of inactivity and storage, she was towed through the Panama Canal to New Orleans. She now regularly travels the Mississippi River as a luxury floating hotel and cruise ship. She is listed in the National Register of Historic Places and operates under a special act of Congress, complete with a special federal post office on board.

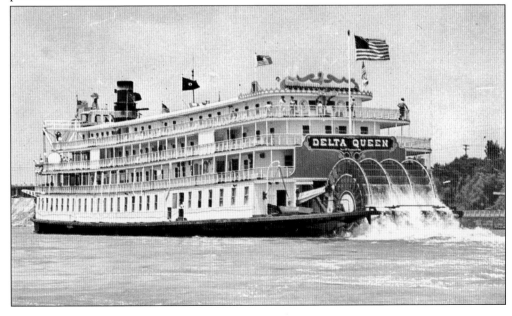

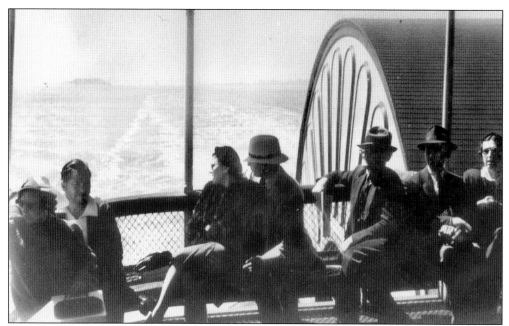

Passengers enjoy riding on the fantail of the *Delta King* on one of its last excursion trips to Sacramento in 1940. Note the view of the Oakland–San Francisco Bay Bridge (also known as the Emperor Norton Bridge) and Treasure Island in the background.

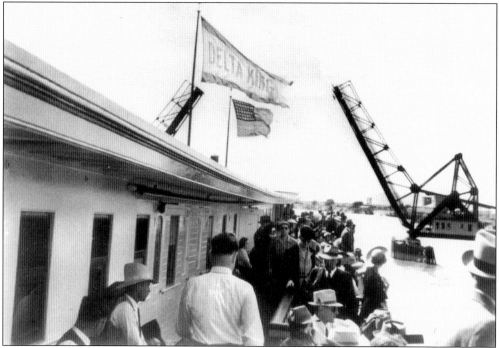

Onboard the *Delta King*, passengers wait and watch as one of the many cantilever (bascule) bridges that span the river lifts to allow the ship to pass. A single cantilever bridge uses a large cement counterweight to lift the span. Sound the ship whistle to raise the bridge and proceed with safe passage.

20

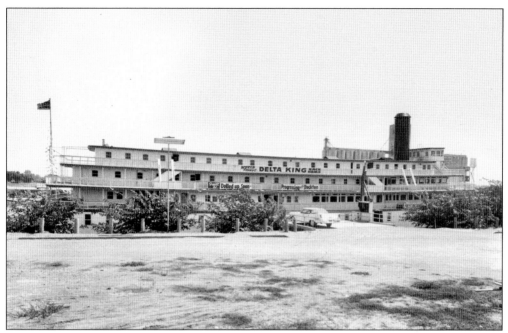

The *Delta King* was restored and moored in Stockton after it sank ignominiously in the inner harbor of Red Rock Marina in Richmond. It lay on the bottom for 15 months before it was rescued and restored.

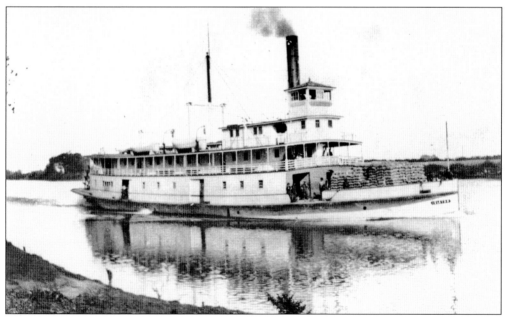

The steam stern-wheeler *Isleton* is seen en route with a cargo of grain. The 176-foot *Isleton* plied the river from 1902 to 1944, making regular stops to take on passengers and freight. Unlike many riverboats, she carried passenger lifeboats. She and her sister ship, *Pride of the River*, were built 20 years apart and privately sailed until World War II.

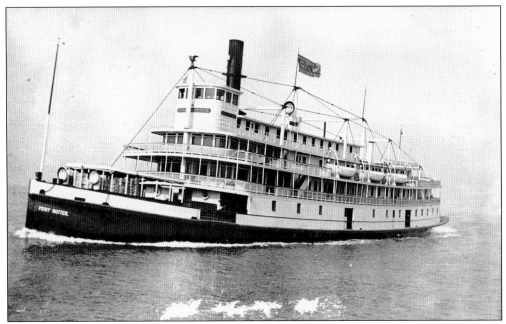

The 219-foot stern-wheeler *Fort Sutter*, built for trade between San Francisco and Sacramento, was launched in 1912. Along with sister steamer *Capital City*, she offered more amenities than any stern-wheeler in the delta until the *Delta King* and *Delta Queen* were launched in 1927. The *Fort Sutter* was destroyed in a fire on a San Francisco beach on May 2, 1959.

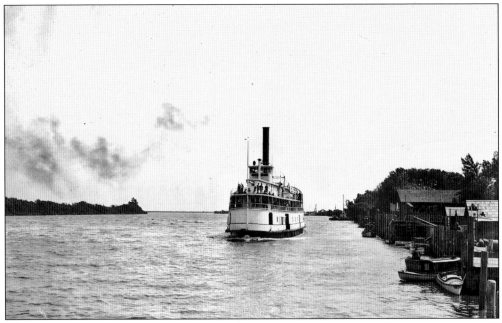

Some of the railroads also got into the steamboat business. For many years, Southern Pacific touted its Netherlands Route. The company found that many of its transcontinental railroad customers enjoyed taking the portion of the trip between San Francisco and Sacramento aboard "luxurious" paddle steamers, such as the 252-foot *Navajo* pictured here. The *Navajo* was built in 1909 by the Southern Pacific Railway, Oakland.

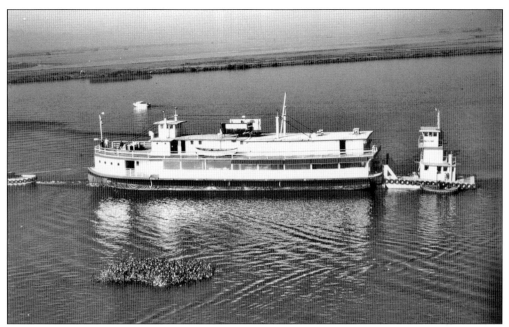

On October 6, 1994, Capt. John Moore's Riverboat Restaurant (*Sutter*) began her move from the Mokelumne River to her new and final home on Dutch Slough on Bethel Island. She serves today as the floating clubhouse for the San Joaquin Yacht Club.

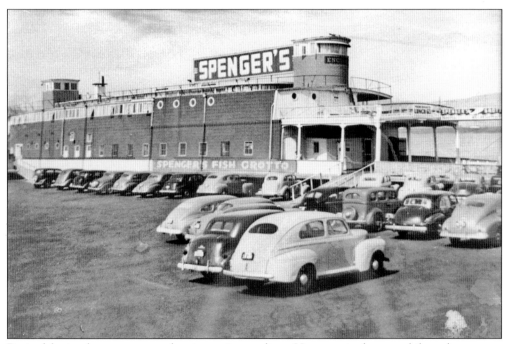

Retired ferries do not go away, they just gain new lives. Here a retired automobile and passenger ferry moored at the old ferry slip in Berkeley houses the first Spenger's Fish Grotto restaurant. The restaurant later moved from the ferry across the parking lot to its present building location on dry land.

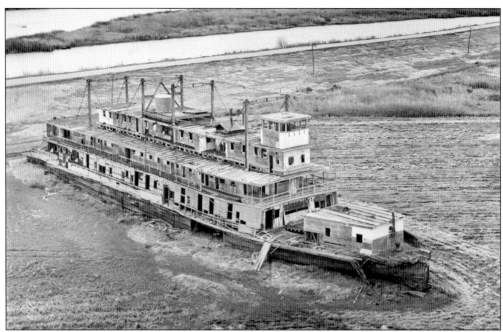

The 252-foot stern-wheeler *Navajo* (above) is shown landlocked on Mandeville Island and surrounded by crops. The *Navajo* and three other derelict ferries were stripped of their engines and floated through the breached levee onto Mandeville Island in 1938 to block the breach. The still-functioning *J. D. Peters* moved into position and pushed the floodwaters off the submerged island with its paddle wheel until it also became grounded. The ships were later used as bunkhouses and cooking sheds. The "potato boat" *Mandeville* (below), the last of what was once a formidable fleet, is hidden away in the tule grass of a remote island and abandoned. All four great ships were eventually destroyed by fire.

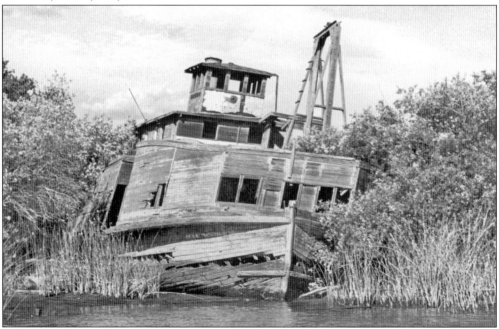

Two

RAILROADS AND TRANSPORTATION

A new era began in the California Delta on May 10, 1869, when the golden spike was driven in Promontory, Utah, and the Transcontinental Railroad was declared complete. This great feat brought with it a rash of other rail projects, both in the greater delta region and elsewhere in California. People living in what had been considered the remote delta now could travel and could ship the produce of their farms and orchards by rail, water, or a combination of the two.

The western portion of the Transcontinental Railroad was made possible by the finances and business acumen of the Central Pacific Railroad Company's "Big Four": Collis P. Huntington, Leland Stanford, Mark Hopkins, and Charles Crocker. The company later became the giant Southern Pacific Railroad, which continues to operate today. The Big Four did not take kindly to competition and often acquired smaller railroads in the area, such as the San Pablo and Tulare Railroad, which installed a short line from Martinez to Banta in 1878. About that time, the Central Pacific Railroad Company also acquired the controlling interest in the California Pacific Railroad, which had a line from Sacramento to Vallejo.

The railroads quickly entered the steamboat business. The Transcontinental Railroad, completed in 1869, terminated at Sacramento. The final leg of the journey to San Francisco was by paddle wheeler until 1879. For many years, the Southern Pacific Railroad touted its Netherlands Route via Rio Vista. Many of its transcontinental customers enjoyed taking the portion of the rail trip between San Francisco and Sacramento aboard "luxurious" paddle steamers such as *Navajo* and *Seminole*. Price wars over steamboat fares were often to the public's benefit.

The railroads helped establish some of the delta-area towns we know and love today. The selection of routes and station house locations for the San Pablo and Tulare Railroad helped bring us such settlements as Brentwood, Byron, Bethany, and Tracy. The railroads also helped establish Lodi (originally called Mokelumne Station) when Western Pacific brought rail lines in around 1869. The San Francisco and San Joaquin Railroad, which became the Santa Fe Railroad in 1898, constructed a line that ran over the San Joaquin River in Stockton, passed into Holt, went through the tules and over the bridges at Middle River (Noorland Station) and Old River (Orwood Station), and connected to Antioch.

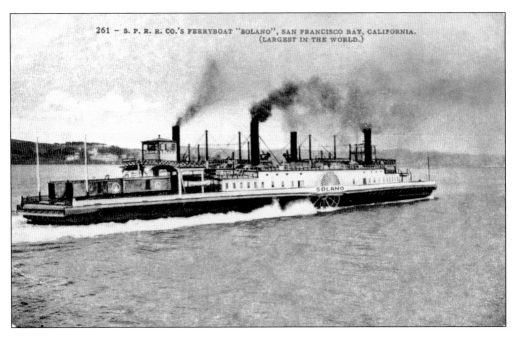

The 420-foot ferryboat *Solano* (above), built in 1879, could accommodate entire strings of railcars, including locomotives. In December 1879, the Central Pacific began using this ferry to shuttle its transcontinental railcars across Carquinez Strait. The cars then ran on the company's rail lines to Oakland, where they were placed on ferryboats to San Francisco. In 1870, the Central Pacific Railroad Company had purchased a controlling interest in California Pacific Railroad, which had built tracks from Sacramento to Vallejo, some through marshes on the west side of the Sacramento River. *Solano* (below) was the largest ferry ever built for the transport of trains and passengers. It moved smoothly from Benicia to Port Costa and dwarfed many other ships.

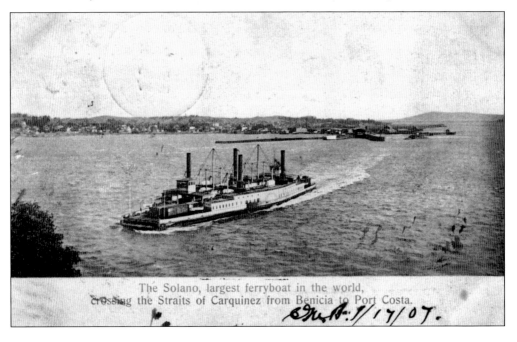

The Solano, largest ferryboat in the world, crossing the Straits of Carquinez from Benicia to Port Costa.

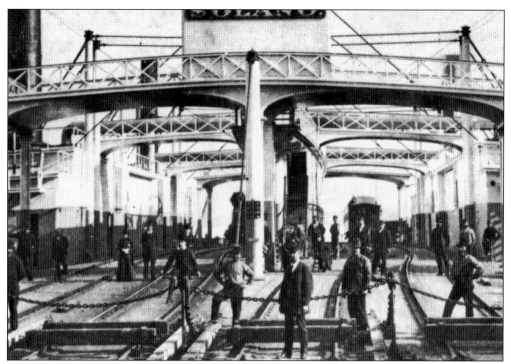

Here is a close-up view of *Solano*'s expansive train deck without cargo. Passengers stayed inside the train compartments and were generally not allowed to roam the deck as the ship made her way between Benicia and Port Costa.

A locomotive pulls into Old Sacramento on an excursion. Engines of this type would have been a common sight between the San Francisco Bay area and Sacramento. Initially, they burned wood; later, they burned coal and, later still, oil. This is a good example of the locomotives that would have been carried by the *Solano*.

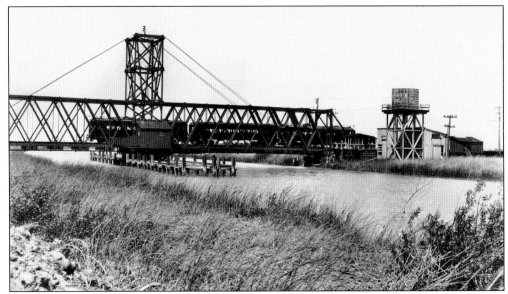

Electric trains of the Sacramento Northern Railroad run across the Montezuma Slough swing bridge in 1925. Trains originating in Sacramento would cross this bridge to Chipps Island, then board the gas-powered ferryboat *Ramon* and cross the Sacramento River to Mallards Landing near Bay Point. They would then go on to Lafayette and Oakland on the Oakland, Antioch, and Eastern Railway. Seven trains left Sacramento daily. The *Ramon* could accommodate six passenger rail cars. Passenger service ended in 1941, and all ferry service ended in 1952.

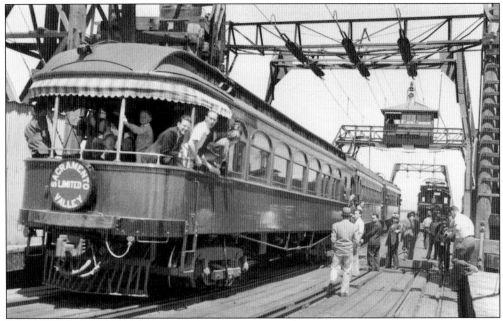

The excursion electric train and parlor car "Bidwell" heads to Sacramento. It is part of the Sacramento Northern Railway, which is similar to the Key System that once traveled the Bay Area and over the San Francisco and Oakland Bay Bridge (Emperor Norton Bridge). The Key (Route) System was a privately owned company providing mass transit to San Francisco and East Bay cities from 1903 to 1960.

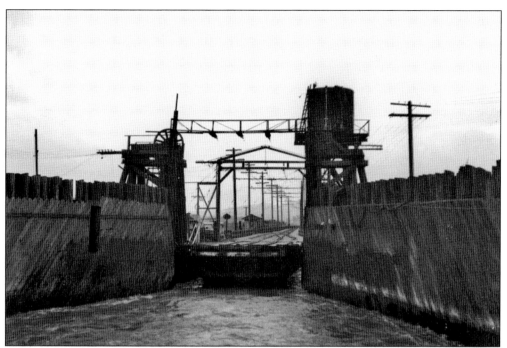

The Sacramento Northern railway slip at Chipps Island is typical of all ferry moles, whether for the giant *Solano* or the tiny *Ramon*. The secret was to line up the tracks on the moving ferry with the stationary tracks on land without losing the railcars in the river.

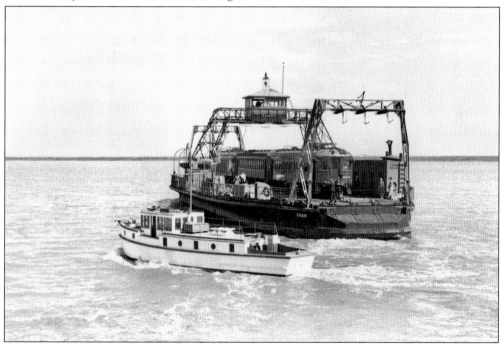

The little train ferry *Ramon* transports the electric cars on the approach to Mallard. There it will connect with the land again and continue on to Sacramento. The accompanying launch is the *Almerla* of San Francisco

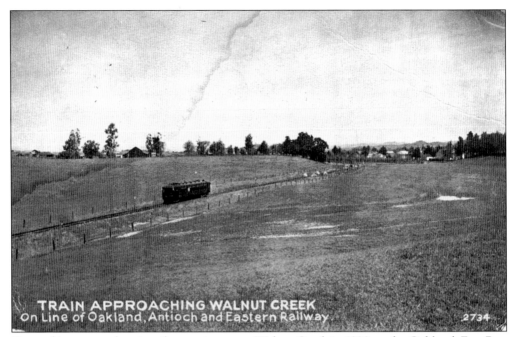

TRAIN APPROACHING WALNUT CREEK
On Line of Oakland, Antioch and Eastern Railway.

2734

Pictured is a trusty electric railcar on its way to Walnut Creek in 1920 on the Oakland, East Bay, and Antioch line. Electric railcars used the same gage track as the Southern Pacific Railcars did. Abandoned rail lines were often converted for use by electric railcars.

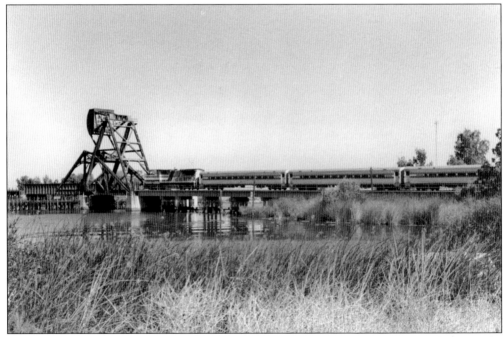

A modern Amtrak train makes its way to Sacramento on the dedicated train bridge over the Middle River in San Joaquin County.

This is a Southern Pacific Railroad map of the San Francisco Bay area and the delta. It indicates all train routes and ferries as they existed in 1910.

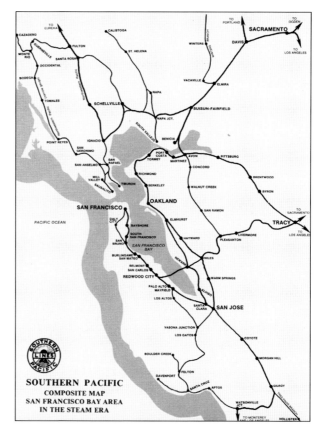

SOUTHERN PACIFIC
COMPOSITE MAP
SAN FRANCISCO BAY AREA
IN THE STEAM ERA

Sonny Welser is pictured here with the original depot sign of the Holt railroad depot. The general store and post office at Holt are now gone.

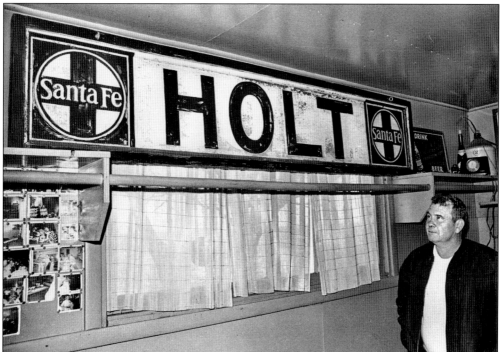

The San Francisco and San Joaquin Railroad, which became the Santa Fe Railroad in 1898, constructed a line that ran over the San Joaquin River in Stockton, passed into Holt, went through the tules and over the bridges at Middle River (Noorland Station) and Old River (Orwood Station), and connected to Antioch. The Holt railroad station pictured here is gone.

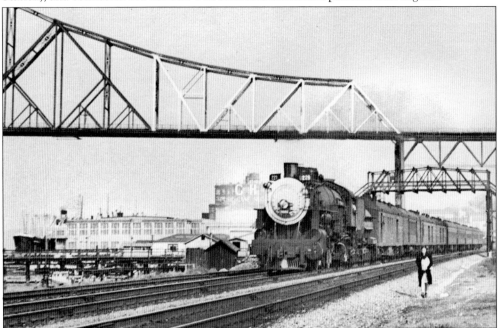

The construction of the new Carquinez highway bridge in 1927, seen here towering over the C&H Sugar refinery at Crockett, was an engineering feat that marked the end of the era of ferries and steam locomotives. The *Solano* ceased operations soon after the bridge was built. Highways, personal automobiles, and trucks brought an end to ship and to railroad transports such as the *Governor*, seen here on its way to Sacramento. (Photograph courtesy of Waldemar Sievers.)

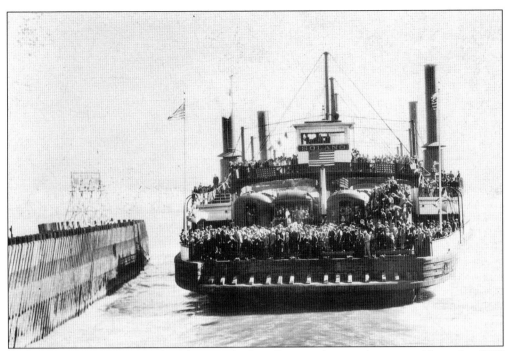

The train ferry *Solano* is seen here leaving the Port Costa mole on its last run in November 1930 before the opening of the Martinez–Benicia Bridge. Imagine the weight carried by the ship in locomotives, cars, and passengers.

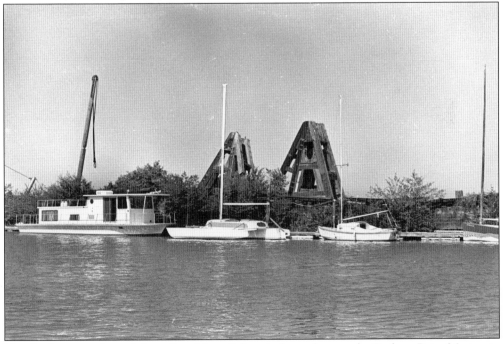

The final resting place of the railroad ferry *Solano* is shown here at the Rodgers Point Marina in Antioch. The great ship served as a breakwater for the marina—quite an ignominious end for the largest ferry ever built.

SANTA FE DEPOT OAKLEY, CAL. 1941

The town of Oakley was established as a shipping point for agricultural products as an expansion of the railroad. The first train arrived on July 1, 1900.

SP DEPOT BRENTWOOD, CAL. 1972

The railroads helped establish some of the delta-area towns we know and love today. The selection of routes and station house locations for the San Pablo and Tulare Railroad helped bring us such settlements as Brentwood, Byron, Bethany, and Tracy. The railroads also helped establish Lodi (originally called Mokelumne Station) when Western Pacific brought rail lines in around 1869.

Three

LEVEES AND RECLAMATION

Reclamation of the California Delta's swampland began around 1849, when Reuben Kerchevel, probably with the aid of local Native Americans, hand-built a protective levee on Grand Island. It was constructed of stacked blocks of peat, which shrank and leaked when they dried. The levee did not last for long, but Kerchevel built new levees that were stronger, higher, and wider. Other delta islands were also reclaimed by hand, including 3,600-acre Twitchell Island in 1869.

The Congressional Act of 1850 granted swamp and overflowed lands to the respective states. By constructing levees and keeping the waters off the land, individuals effectively created new property (islands). A subsequent act of 1858 provided for the sale of these lands by the state to individuals. Settlers could drain, improve, and apply to purchase the most fertile farmland in California. The race was on to create productive land from the marshes.

It soon became clear that substantial levees, built with stronger substances than peat soil, were required. Around 1875, Glasgow California Land Company superintendent John Ferris designed a clamshell dredge for levee building and commissioned its construction. The dredge could move dirt faster and for less money per cubic yard than could the Chinese laborers who toiled on the levees. In later years, dredges were further improved upon by adding more power, bucket capacity, and reach.

At the dawn of the 20th century, levees were going up in earnest. Over 100 clamshell dredges worked in California, most of them in the delta and associated waterways. By 1920, reclamation of the delta was complete. With little work for the dredges, many were abandoned, dismantled, or destroyed. Some 700,000 acres had been reclaimed, and 55 islands were made ready for the plow. In addition, the dredging deepened most of the delta waterways, preparing them for the fleets of pleasure boats that would soon arrive.

Levee failures and flooding are still a part of delta life, although perhaps they are less frequent than they were in earlier times. The threat of flooding is always with the people who farm and recreate in this great area. Levee failure has become a topic of greater concern, both on the state and national levels, in the aftermath of Hurricane Katrina and the levee breaks in New Orleans. It is not a question of whether the California levees will fail, but of when they will fail.

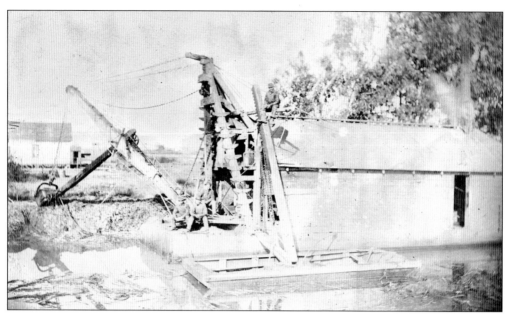

This is how it all began. This non-commercial dredger, photographed in 1920, is essentially a backhoe attached to a flat-bottom boat with a shed on it for protection. The homemade gantry supporting the scoop widens the channel and creates the berm as it goes. Note the flat-bottom skiff alongside, which provides a counterweight. Ted Frates, seated at bottom left, is the proud owner.

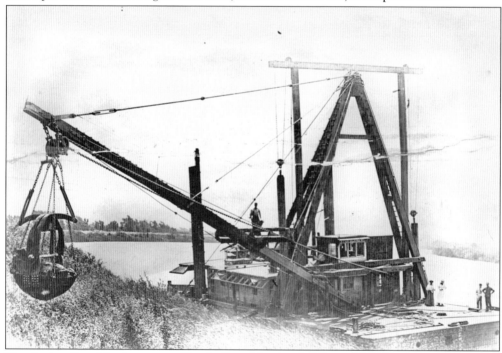

The dredger *Ryer Island* was owned by the Ryer Island reclamation district and was used to build levees. Dredgers, like ferries, were considered ships and were given names. Note the two women on board who have come out on their launch to pose for the photograph, which was taken around 1900.

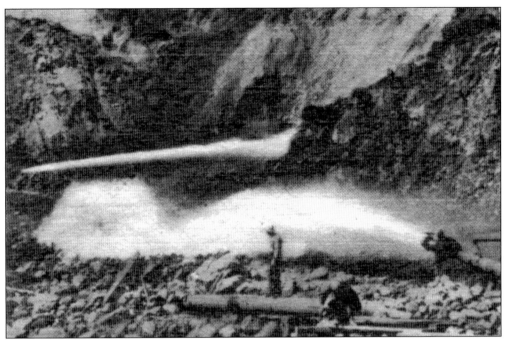

According to early Spanish explorers and fur trappers, the water of the delta rivers was pure and clean. That ended with the Gold Rush and the introduction of hydraulic mining. The water monitors washed mountainsides of soil down the American, Tuolumne, and Mokelumne Rivers. The suspended earth washed down and through the delta, silting and filling it as it went.

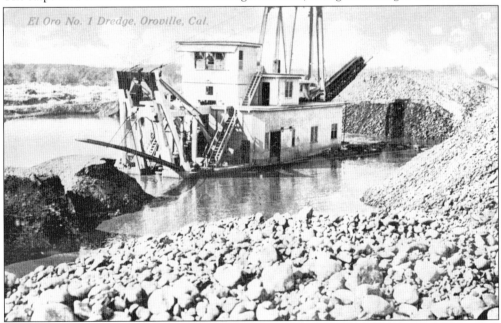

Dredging for gold in Mother Lode River was another source of delta pollution. Potential "pay dirt" was dredged, the ore was extracted with quicksilver (mercury), and the silt, rock, and chemical by-product was released back into the river. The California Delta is a natural filter, but even filters get clogged. Today the delta still suffers from the silting created more than 100 years ago.

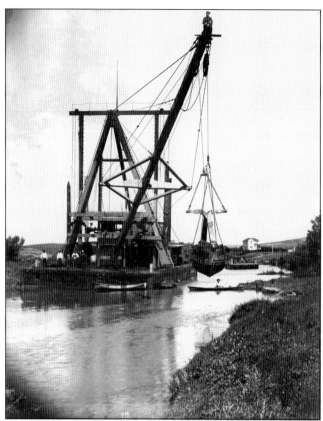

This clamshell dredger on St. Joseph's Cut serves two functions. It widens and deepens the waterway and, at the same time, collects the dirt and debris to be used as material for the levee. The alluvium soil is rich in nutrients for agriculture, but it is hardly a solid foundation for a wide berm. The home of Felix Drouin, Rio Vista, appears on the right.

Chad Buckingham poses with a giant clamshell dredge. Buckingham worked on the dredgers from 1914 until he went into the army during World War I. After the war, he returned to the dredgers several times before moving to San Francisco during World War II to work in the shipyards. (Photograph courtesy of Charles I. Davis.)

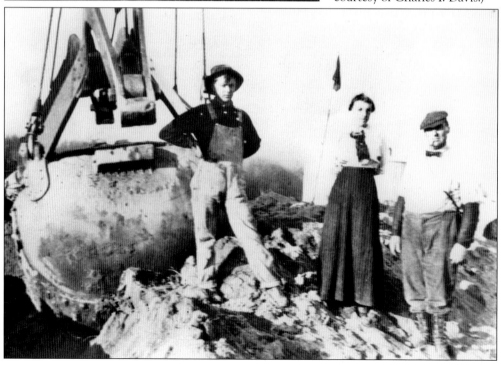

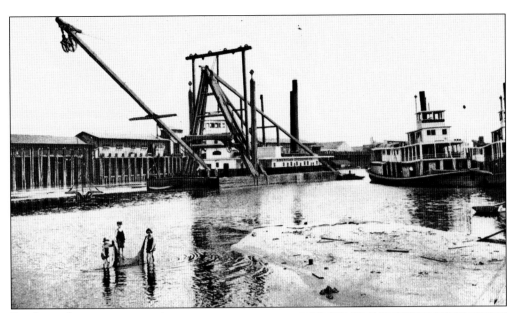

Dredging the river to maintain the shipping channel was a constant job. Water levels could shift dramatically. In this image, the water is not even to the knees of the three small boys with the net, and the dredge and ferry are almost aground. Also note the height of the warehouses, which were built on stilts well above flood level.

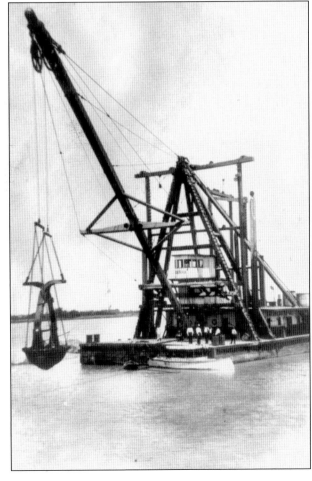

The *Sierra* dredger is pictured here at work around 1919. Commercial dredgers were huge operations, capable of scooping an automobile-sized amount of material. Note the woman on board. It was common for female relatives to accompany or cook for the crew as part of a family operation.

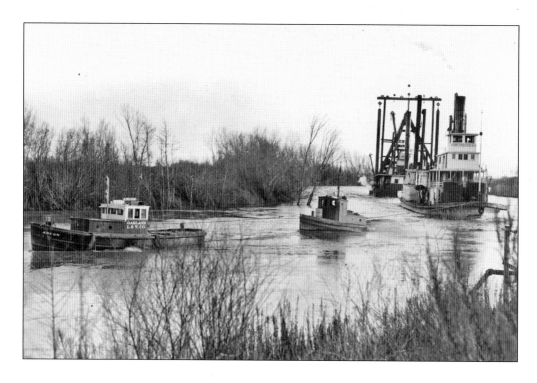

Dredgers are cumbersome, heavy, and hard to navigate. Above, a tugboat, a small boat, and the ferry *San Joaquin* are all in cable to tow a dredger. It is too late to stop the flow of water once a levee has failed; however, the dredger may place sandbags and rocks at the edges of the breach to keep the gap from widening. After the flooded island and river have reached equilibrium, the real work begins: laying down a better foundation and rebuilding the berm. The two ships below are towing a dredger to commence operations.

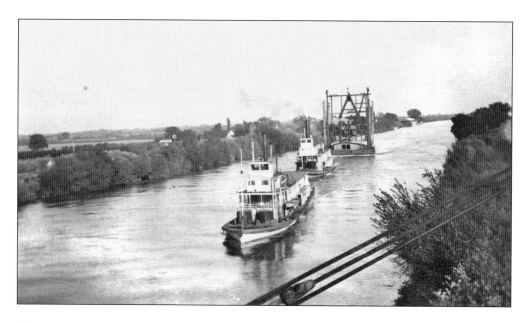

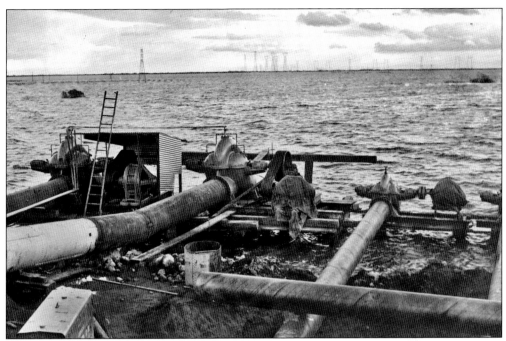

Massive pumps are found on many delta islands because most of the islands were created by draining the marshes in the California Delta. These pumps are strategically positioned on the levees not to pump water from the river onto the land for irrigation, but to pump water out from the land and maintain the property as a dry island. The vast tract of water seen in the image above is not the river but a flooded island. Start the pumps! It can take years to pump out a large island that has flooded due to levee failure (below). Some flooded islands, such as " Antioch's Big Break," are abandoned entirely and become estuaries.

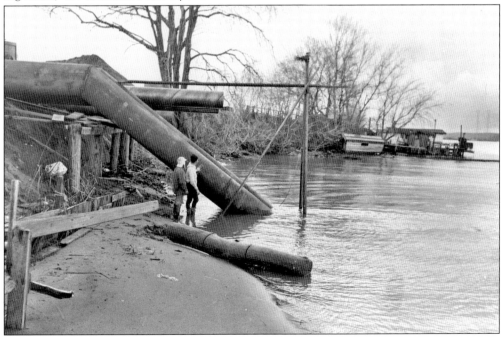

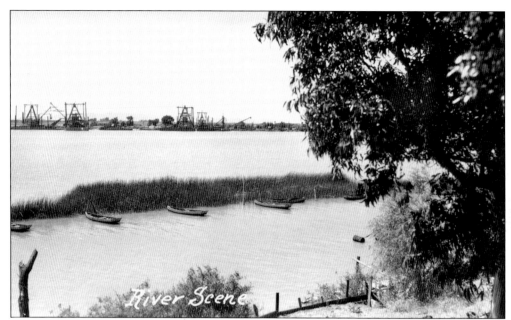

Fishing boats for hire at a natural marina are protected from the main Sacramento River Channel. Commercial dredgers line up along the far bank, awaiting work.

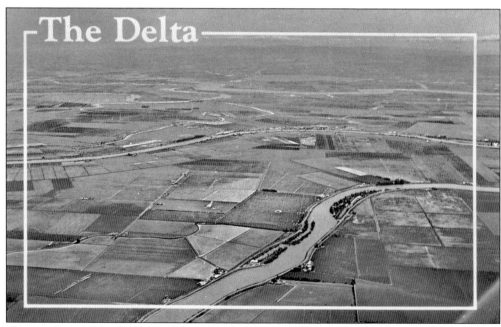

This aerial view of the California Delta shows the agricultural bounty that dredging has brought about by creating islands. Each island was reclaimed from the marshes, and water transportation to them is provided through the main river channel. None of this would have been commercially possible without the dredging and reclamation of marshland, transforming it into productive farmland.

Four

FERRIES AND BRIDGES

Explorers, mountain men, gold seekers, and other early visitors to the California Delta had to reckon with getting across the myriad waterways that form this wonderful place. Crude ferries were among the delta's early business enterprises. Even after towns and cities began to be established in the delta, ferries continued to be the prime means by which travelers crossed the waterways. A simple trip from Lodi to Rio Vista, for example, might require as many as five ferry crossings.

Later, as bridges replaced some of the ferries, it was necessary to construct usable bridges— drawbridges—so that boat traffic could continue to navigate the waterways. When "horseless carriages" came on the scene in ever-increasing numbers, more ferries were put into operation, and more drawbridges were built. San Joaquin County licensed 12 ferries in 1850.

Drawbridges come in three principal varieties. Swing drawbridges, which have a frail, almost homemade appearance, open by pivoting sideways, much like the old railroad turntables. Bascule drawbridges, also known as cantilever bridges, open like the drawbridges over castle moats. Vertical-lift drawbridges open by lowering counterweights that are the exact weight of the lift span; they are easily recognized by the pairs of high towers that house the counterweights. Vertical-lift bridges are efficient, fast, and need to only open high enough for the passing vessel to clear. Most tended drawbridges will open on signal: one long and one short toot of the horn. Others can be contacted by VHF marine radio.

Today there are still over 70 drawbridges and quite a few ferries in the delta. Most have changed little in the last 75 to 100 years. They are a nostalgic reminder of the delta's past, of a time when life was a little slower. People who live in and visit the delta feel that they add a lot of charm to the place.

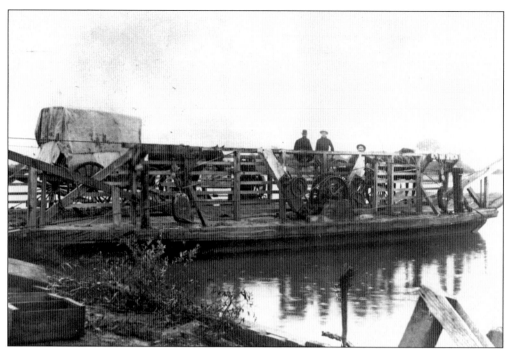

The first regularly scheduled passage cable ferry, *Alma* (above), was located two miles north of Rio Vista. It is seen here around 1900. The *Alma*, owned and operated by Fred Lauritzen, traveled between the mainland, Grand Island, and Brannan Island. One could not travel very far in the delta without using some sort of water transport. These first ferries moved wagons, equipment, livestock, and passengers across narrow sloughs using a greased cable. Horsepower or tidal power moved the craft along. Later, small engines provided the power. If you look carefully, you can just make out the single greased cable extending fore and aft and guided along the railing (below).

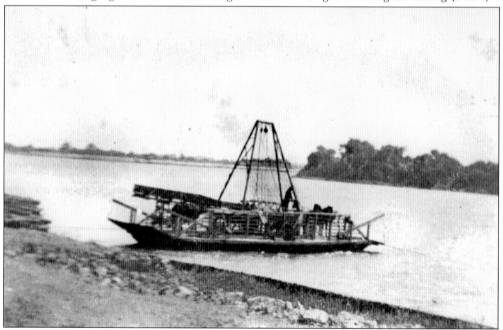

Operating cable ferries often became a family vocation. The Ryer ferry (above) provided early service to Ryder Island, the island reclaimed by Dr. Ryer in 1865. The ferry tender, like the bridge tenders of later years, lived nearby and responded to hails for transport across the water. He traveled a lot but never far. Fares varied: they were higher for wagons and lower for individuals. The cable ferry at the Sacramento River at Walnut Grove (below) saw active business.

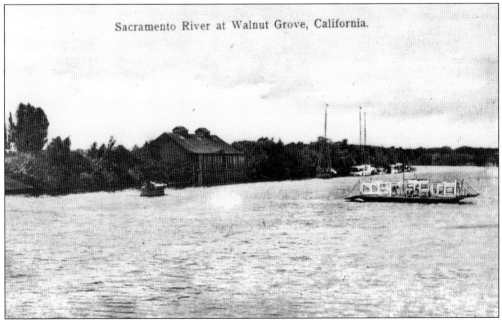

Sacramento River at Walnut Grove, California.

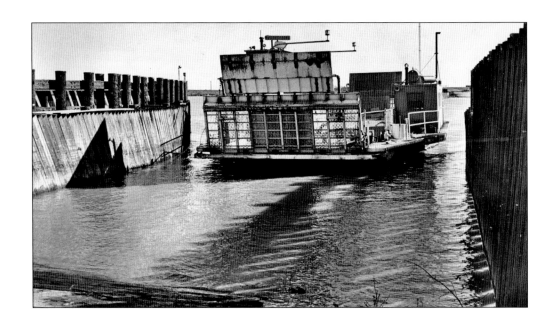

Ferry operators providing transport over navigable channels found cables impracticable as well as a hazard to navigation. The "Real McCoy" ferry (above), seen here entering its mole at Ryer Island, was self propelled and could handle automobiles, recreational vehicles, and teamsters' heavy loads. The cable ferry below is restricted to short spans and passes back and forth like a spider along its web.

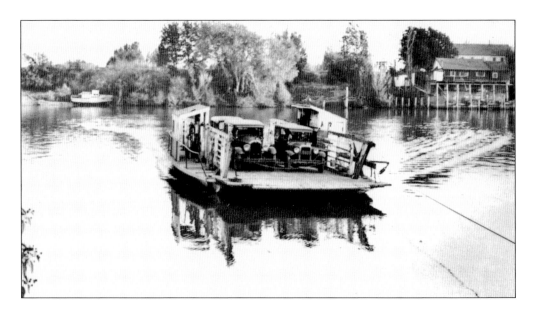

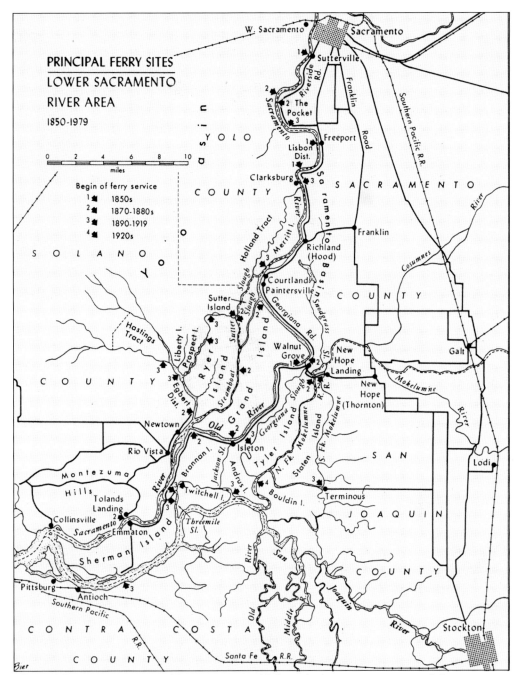

PRINCIPAL FERRY SITES
LOWER SACRAMENTO
RIVER AREA
1850-1979

miles

Begin of ferry service
1 1850s
2 1870-1880s
3 1890-1919
4 1920s

W. Sacramento Sacramento

Sutterville

The Pocket

Freeport

Lisbon Dist.

Clarksburg

YOLO COUNTY

SACRAMENTO COUNTY

SOLANO COUNTY

Franklin

Richland (Hood)

Courtland
Paintersville

Sutter Island

Walnut Grove

New Hope Landing

New Hope (Thornton)

Galt

Liberty I.
Prospect I.
Ryer Island
Sutter Island
Grand Island
Egbert Dist.
Steamboat Slough

Newtown

Rio Vista

Isleton

Brannon I.
Jackson Sl.
Andrus I.
Tyler Island
Staten Island

Montezuma Hills
Tolands Landing

Collinsville
Emmaton
Sacramento

Sherman Island

Twitchell I.
Bouldin I.
Threemile Sl.

Terminus

JOAQUIN

Lodi

SAN

Pittsburg
Antioch
Southern Pacific

CONTRA COSTA COUNTY

Santa Fe R.R.

Stockton

Mokelumne River

Cosumnes

Bier

The California Department of Transportation (Caltrans) now maintains most of the remaining delta ferries, although a few private ferries still exist. Most ferries require notice up to 24 hours in advance for transport. The private ferries deliver to private agricultural islands, where there is no place to go once you have arrived.

47

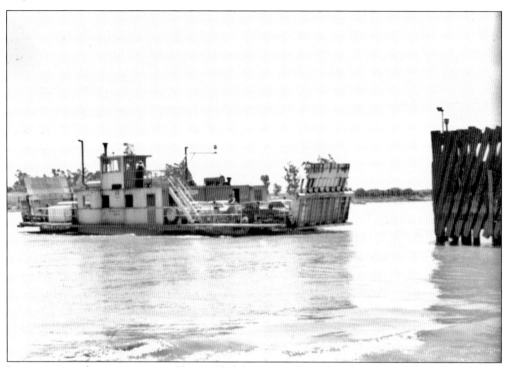

Larger spans of water require self-propelled ferries, such as this Ryer Island ferry shown as it approaches the mole (above) and as it takes on passengers (below) for a trip from Rio Vista to the island.

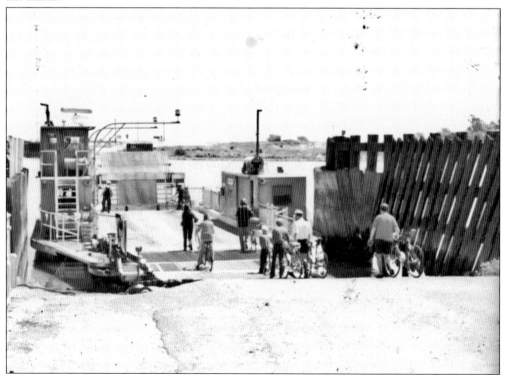

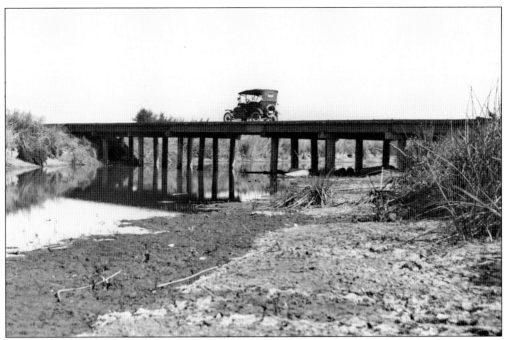

One by one, bridges replaced the ferries as the ubiquitous automobile took the lead in transportation, traveling over ribbons of new highways. This Ford Model A transverses an early wooden bridge over a small slough. No river transport was needed here, and there was no river traffic to contend with.

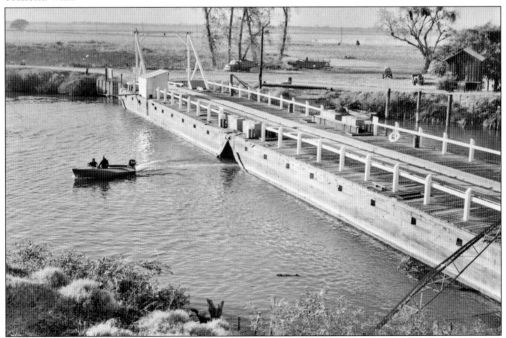

Small byways can make-do with inexpensive pontoon bridges. Here a small fishing boat slips between two segments of the bridge. This setup works well for areas with little water commerce or traffic.

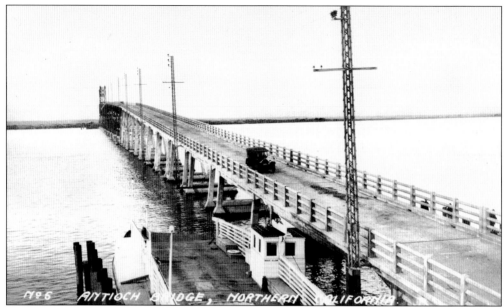

In January 1926, the Antioch Bridge (above), described as the "Gateway to the Netherlands of America," was completed, becoming the first toll bridge on San Francisco Bay. It remained a privately owned and operated bridge until 1940, when the state bought it. Travelers were encouraged to travel to Sacramento on the Victory (Lincoln) Highway via the delta. Postcards such as the one below provided a convenient map to help travelers enjoy the trip. Traveling along the river by car was made easy by the bridge spanning the San Joaquin River—an engineering marvel. A vertical-lift drawbridge covers the deepwater channel to accommodate large ship traffic. The self-powered Sherman Island ferry waits in case of a problem with the lift. The lift on the bridge was plagued with mechanical failures over the years, which caused interruptions in shipping traffic. The trusty car ferry once more came into service.

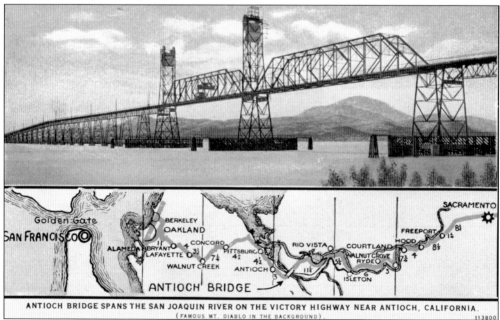

ANTIOCH BRIDGE SPANS THE SAN JOAQUIN RIVER ON THE VICTORY HIGHWAY NEAR ANTIOCH, CALIFORNIA.
(FAMOUS MT. DIABLO IN THE BACKGROUND).

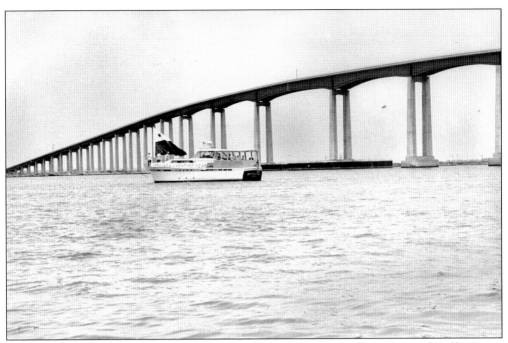

The old Antioch Bridge was one mile long, 31 feet wide, and carried two lanes of traffic. It was plagued by constant traffic holdups. The new bridge, built at a cost of $35 million, is 1.8 miles long and 40 feet wide, with shoulders for bicycles and for emergency use. It clears 135 feet vertically and 400 feet horizontally.

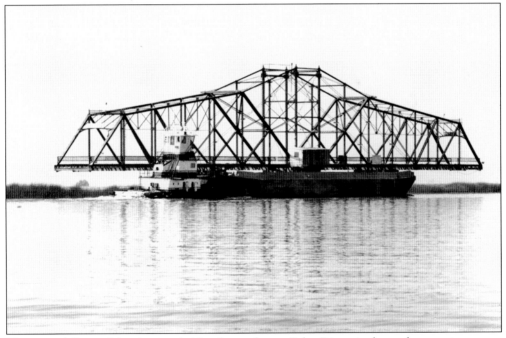

The retired Bacon Island swing bridge, located near False River, is shown here on its way to Oakland and the wrecking yard. While this bridge was floated away on a barge for recycling, the original Antioch Bridge met its demise by explosives.

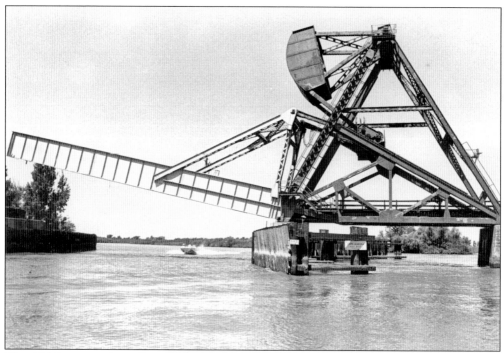

This Old River cantilever (bascule) bridge closes to let Amtrak trains and other Santa Fe Railroad trains pass. Normally, bridges lift to allow watercraft to pass underneath. In this case, the ships stop to let the trains pass.

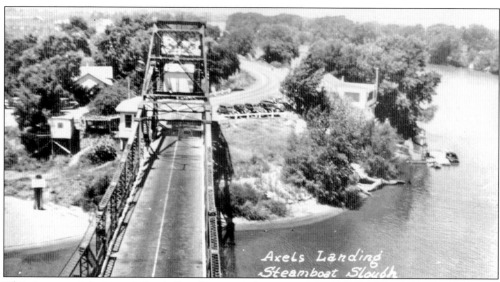

This is an aerial view of Axels Landing and the entrance to Steamboat Slough. Note the sandbar to the left of the bridge, which provided a constant hazard to navigation and a lovely sunbathing beach.

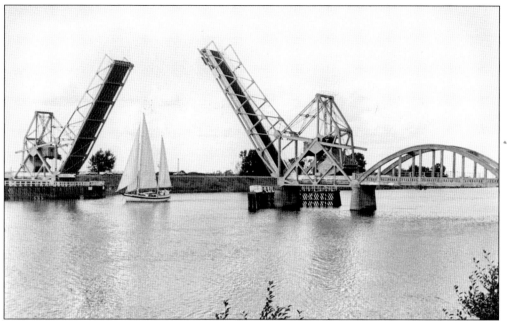

Pictured here is the Walnut Grove double bridge. A constant breeze allows recreational sailors to travel to Sacramento without auxiliary power.

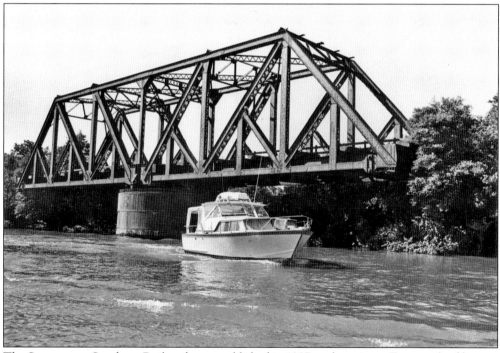

The Sacramento Southern Railroad was established in 1907, and service to Freeport (and later to Hood) commenced in June 1909. Completion of this swing bridge, which passes over Snodgrass Slough near the town of Locke, extended the railroad line to Walnut Grove in 1912. By then, Central Pacific, later to become Southern Pacific, owned the line, which became known as the Walnut Grove Branch Line.

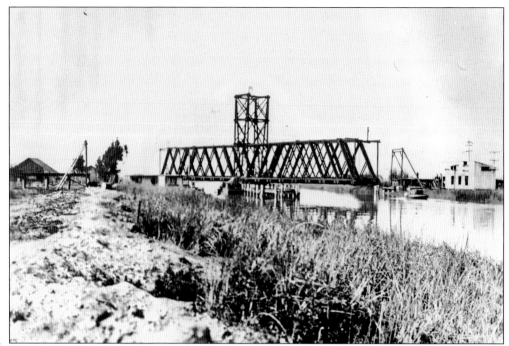

Pictured here is a swing bridge.

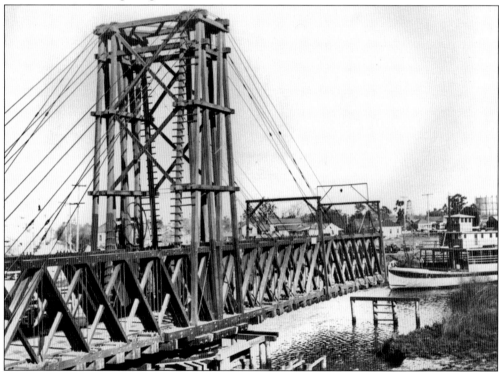

This devilish Stockton Bridge over Morman Channel served railroad trains and wagons, but it was hated by motorists. It was a vital part of the Borden Delta Highway and was on the main route to Yosemite.

Delays in the completion of the first railroad bridge at Mossdale required that transcontinental railroad customers cross the San Joaquin River via ferry during its first 60 days of operation.

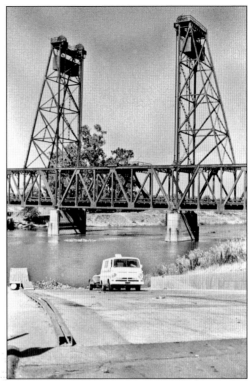

This image is of the Three Mile Island Bridge.

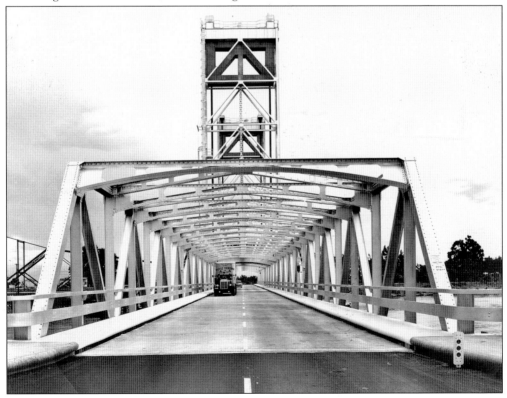

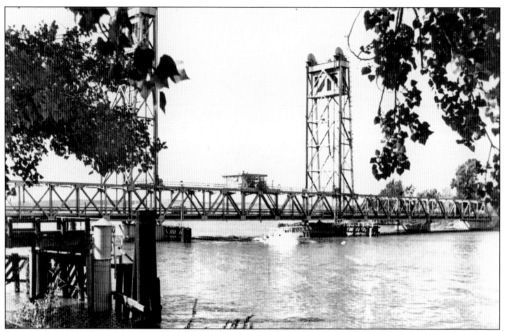

Pictured is the Three Mile Island Bridge in the down position. The lifting mechanism raises and lowers the center span with the aid of massive counterweights. It is all a balancing act. The center span travels easily up and down along greased wheels as long as nothing causes the vertical lift to vary from 90 degrees.

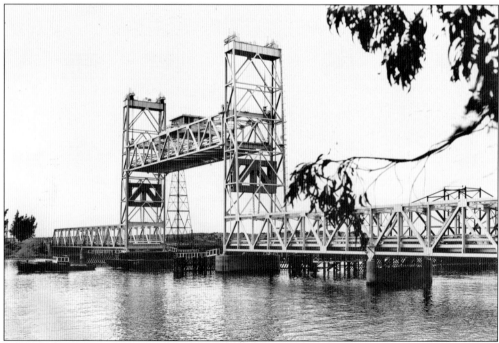

Here the Three Mile Island Bridge is in the up position to allow a boat to pass. Note the relatively small size of the ship passing under with a barge in tow. Today commercial ships must wait until nighttime to pass in order to minimize traffic congestion for commuters.

Five

COMMUNITIES AND HAMLETS

The quiet delta drive on both sides of the Sacramento River preserves an earlier era of small-town California with its rural base. Sacramento City lay to the north and Stockton on the east side of the California Delta. These are large, metropolitan cities, and for the traveler, the charm of the delta lies in the small towns along the river. Highway 160 is the main road traveling along the labyrinth of navigable waterways.

Those who did not strike it rich in the goldfields turned to agriculture to sustain themselves. Often each landowner had a wharf from which to ship crops or transship produce to a deepwater port. The towns that developed were created at these commerce and trade ports. It is still that way today, although automobiles have replaced sloughs and paddle wheelers as the primary mode of transportation. Delta towns continue to be small communities or hamlets, often with fewer than 500 residents.

Fighting discrimination at every turn, some Chinese formed their own city, Locke, in 1916 after fire destroyed the Chinatown area of nearby Walnut Grove. Today you can browse Locke and still find a few Chinese merchants. With about 50 residents, Locke is now a ghost of its former flourishing life. It once boasted a theater, six restaurants, and a fluctuating number of brothels. You can visit the Dai Loy Museum, once a gambling hall, to see photographs and artifacts from the heyday of the town.

Beyond the streets of Locke, an appropriate delta excursion is up and down the roads on both banks of the Sacramento River. People in the small delta towns are a gregarious mix of Americans of various descents, including Chinese, Japanese, Portuguese, Italians, and Filipinos. Though their lives are usually passed in such sober pursuits as raising food crops, running resorts, and tending shops, delta people possess a streak of eccentricity. Foster's Bighorn Café in Rio Vista displays a famous collection of mounted African big game animals. One interesting delta trip is the 20-mile Tyler Loop out of Walnut Grove, which you can make by car, bicycle, or boat. You will pass Georgiana Slough, one of the most beautiful delta waterways, lined with willow, poplar, and oak trees.

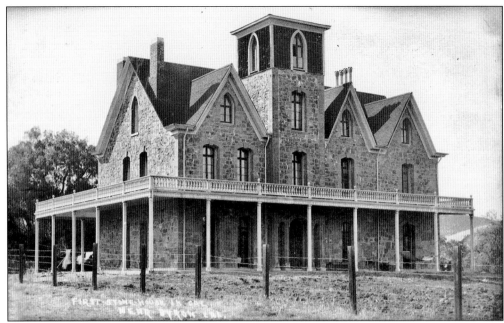

John Marsh, the first European American to settle the great Central Valley, selected the delta as his home (above). Marsh had seen all of the American frontiers, and he selected the area bordered on the west by Mount Diablo and on the north and east by the San Joaquin River as the site of his Rancho Los Meganos. He established many crops in the region that we take for granted today, including wheat and various orchard fruits, and introduced the practices of animal husbandry and viticulture. Marsh established California's first inland port at Marsh Landing (below), located between what is now Antioch and Oakley, to allow the transport of grain and cattle to market.

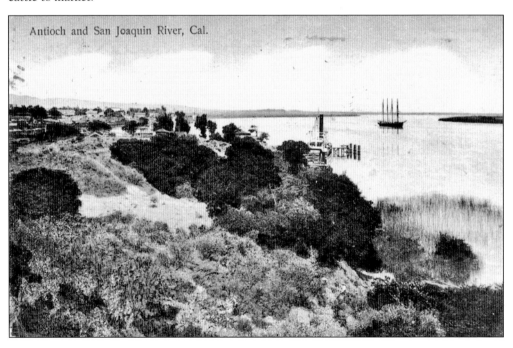

Antioch and San Joaquin River, Cal.

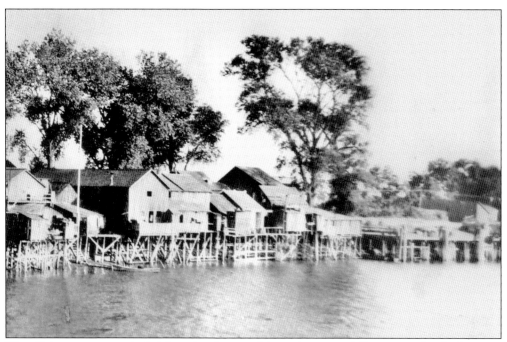

The Chinese were precluded from land ownership and were socially marginalized whenever possible. This shantytown of stilt houses over the water in Courtland is a physical reminder of how their employment and their lives were kept perilously on edge.

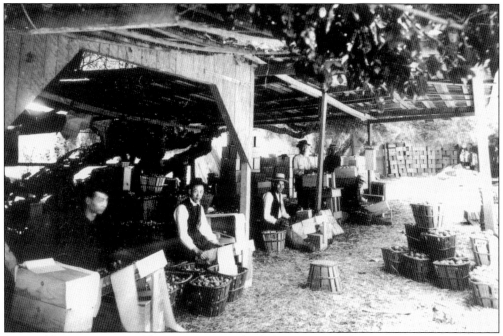

Pictured here c. 1900 is a Chinese "Runyon Shed" for sorting produce in Courtland. Note that there are no women helping to sort and pack the potatoes and vegetables. The Chinese Exclusion Act of 1868 effectively halted the arrival of Chinese women in the United States. The communities of Locke and Courtland were essentially Chinese bachelor towns.

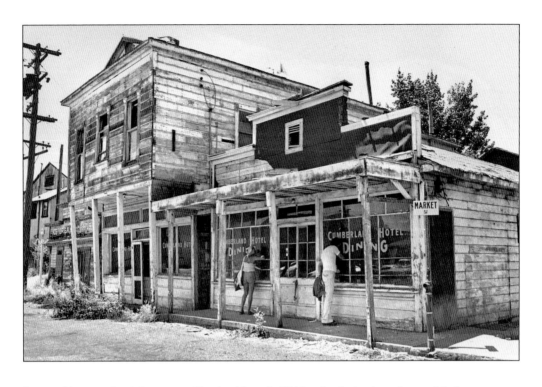

Pictured here is the delta town of Locke (above). Old Locke (below) is a beautiful place to visit. It has not changed much over the years, and a walk through town is worth every moment. Dock your boat and take a walk over the levee.

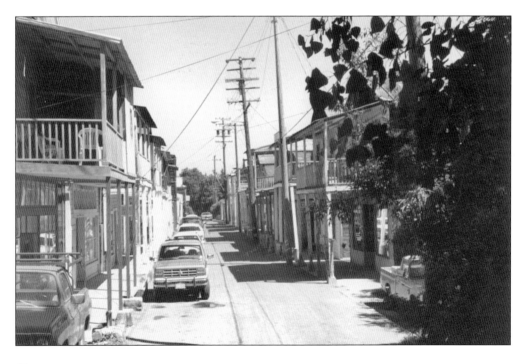

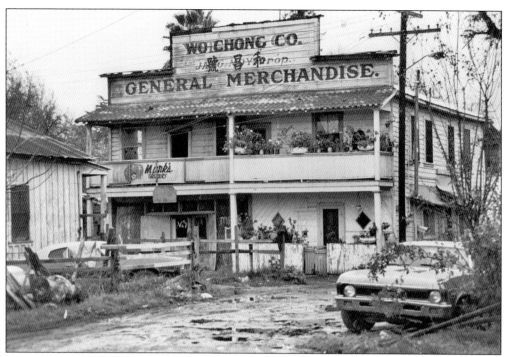

Most towns in the delta had a Chinese district and merchants who catered to Chinese clientele and tastes. This Chinese store in Courtland, now unused, sits a few feet away from State Highway 160, and it can easily be overlooked from the vantage point of the highway.

Not all buildings in Courtland are in disrepair. The proud Bank of Courtland building attests to the economic prosperity of the community in earlier days.

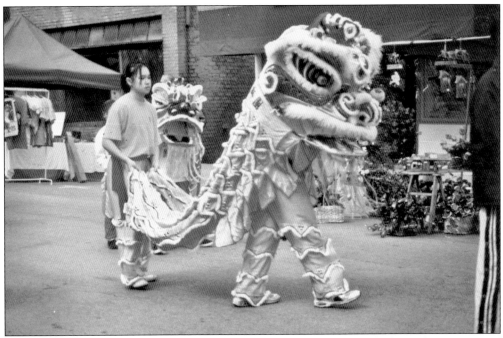

A Chinese dragon troop, dancing and bringing the community good luck, is always a part of the cultural traditions associated with any celebration in Locke. Over the years, the number of Chinese Americans in this community, which was once predominantly Chinese, has dropped to less than a dozen.

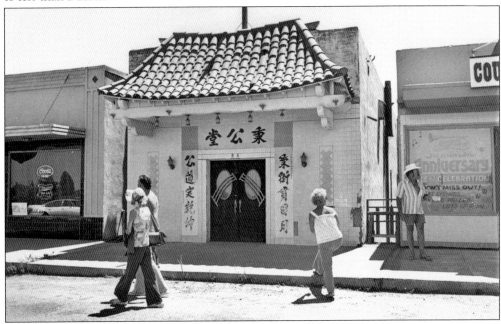

This presumed "Chinese Temple" in Walnut Grove is not what it seems. Note the art nouveau, double-swinging door to a saloon. The east bank of the river is the main commercial section of town. The town was founded in 1851 and was home to a busy sawmill that provided lumber and fuel.

Pictured is the schoolhouse in Isleton.

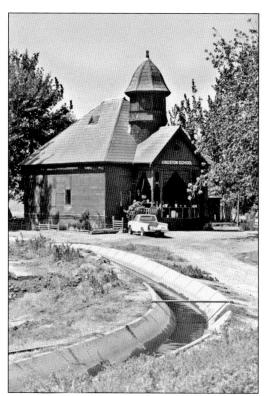

Teachers and students pose in front of the schoolhouse for the annual photograph in the 1910s.

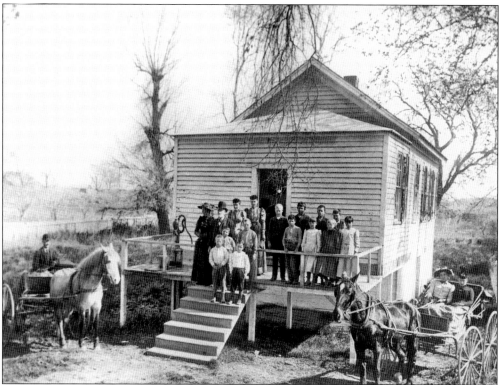

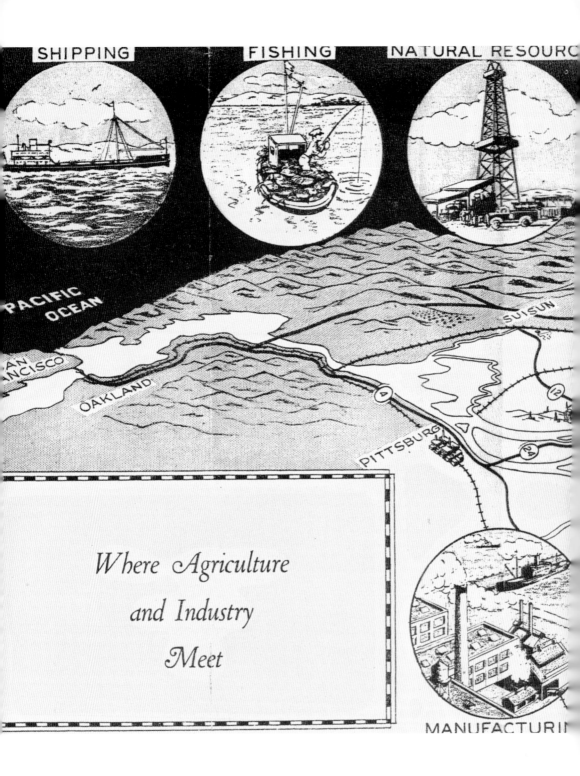

SHIPPING FISHING NATURAL RESOURC

PACIFIC OCEAN

SAN FRANCISCO

OAKLAND

SUISUN

PITTSBURG

Where Agriculture

and Industry

Meet

MANUFACTURI

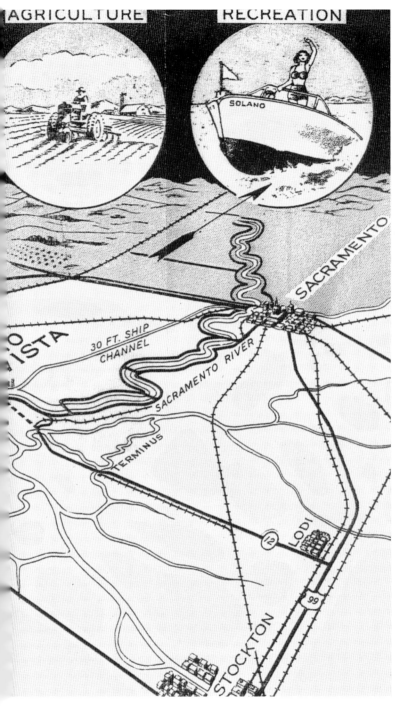

This is a promotional illustrated map of the California Delta distributed by the Rio Vista Chamber of Commerce. It provides an excellent overview showing the extent of the delta and major state highways. Not surprisingly, Rio Vista with its recreational, agricultural, and natural resources is at its heart.

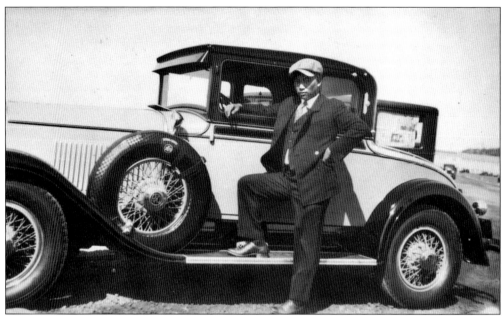

Good money could be made at the canneries, as evidenced by this image of a Filipino American migrant worker poised on the running board of his new REO coupe. He wears a three-piece suit and a jaunty cloth cap. Agricultural labor was hard to find during and after World War II. Many Filipinos came to California to fill the need.

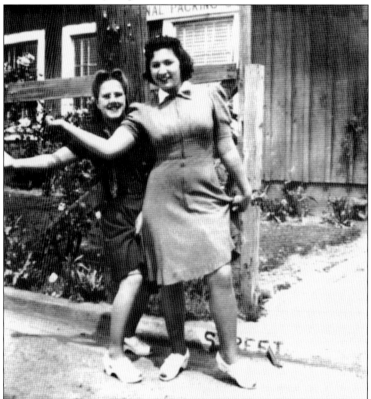

Claudette Colbert, who starred in *It Happened One Night* in 1934, had nothing on these girls, who are hitching a ride after a shift at the packing shed. Perhaps they hope their Clark Gable will happen by in a two-toned coupe.

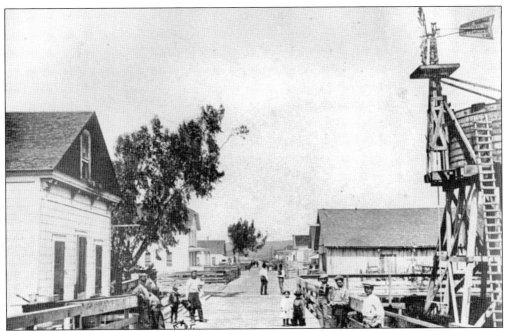

Collinsville, located just across the river to the north of present-day Antioch, was a bustling agricultural community with a wharf and active river traffic. Today it is generally considered the westernmost edge of the delta. The town is long abandoned and now is better known as a wind-turbine generator farm.

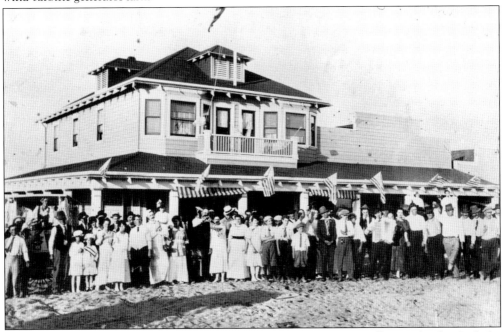

Between 1906 and 1916, Vorden had a wharf, two grocery stores, a post office, a school, a Catholic chapel, several homes, and a hotel, the River Rat, pictured here. The hotel had eight bedrooms, a bar, a grocery store, and a general store. Seven-course Italian dinners were offered at a price of $1, not including tip. Every Saturday, 300 ravioli were prepared for the week.

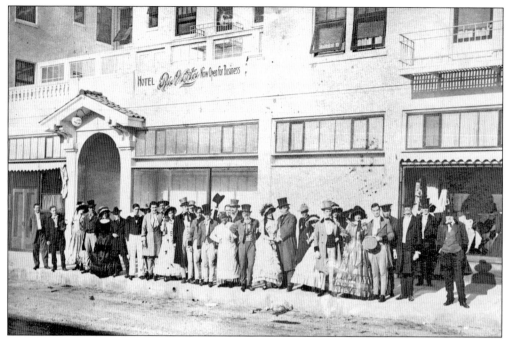

The full cast of the 1914 silent film *Cameo Kirby*, filmed in Rio Vista, poses in front of the Rio Vista Hotel. Leading the cast of players in the title role is Dustin Farnum, known later for his role in the landmark western *The Virginian*. The delta provided the backdrop for the antebellum melodrama, which was set on a New Orleans riverboat.

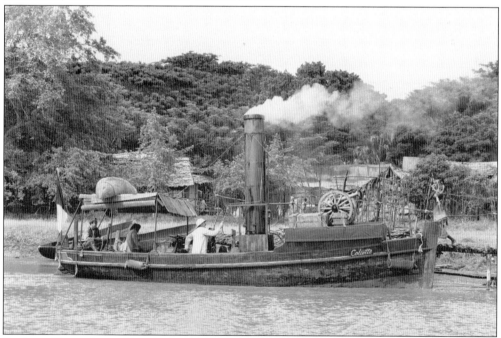

Producer George Lucas filmed parts of *The Young Indiana Jones Chronicles*, a television series that ran from 1992 to 1996, along the Sacramento River. In this scene, Sean Patrick Flanery, as youthful archeological treasurer hunter Indiana Jones, pilots his steamboat to his next adventure.

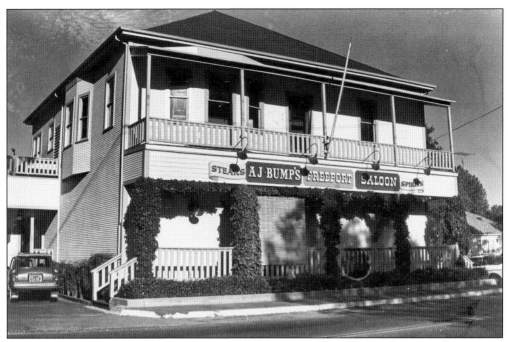

Freeport, now a commuter suburb of Sacramento, is just south of the Pocket area of the Sacramento River. It retains its charm and is only minutes from good employment opportunities in the capitol city.

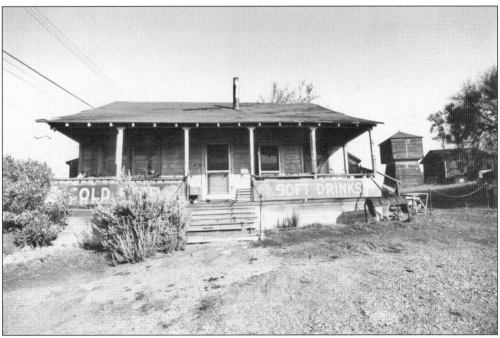

Birds Landing provided a good backdrop for the 1986 film *Honkey Tonk Man*, which starred Clint Eastwood. All that is left of the town now is this general store and bar. The walls are covered with photographs of local interest

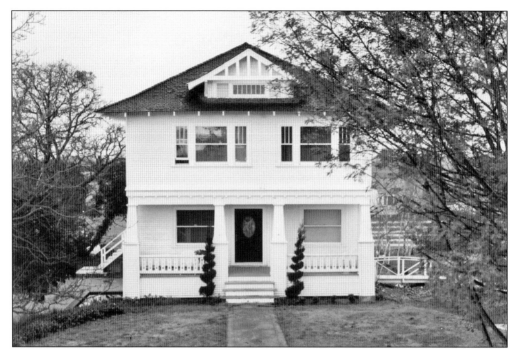

The typical river house is a two-story affair. The second story often peeks over the levee to the water. This tidy home, set in a prosperous pear orchard, sits below the level of the river. In case of flooding, one should open all the doors and windows on the first floor and retreat to the second floor.

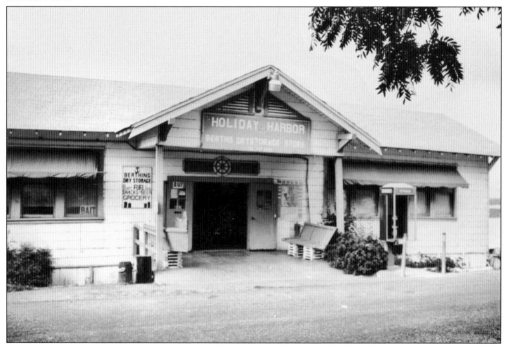

This former schoolhouse, which now serves as a storage building for the King Island Resort, provides a bit of nostalgia on Disappointment Slough (pronounced "sloo").

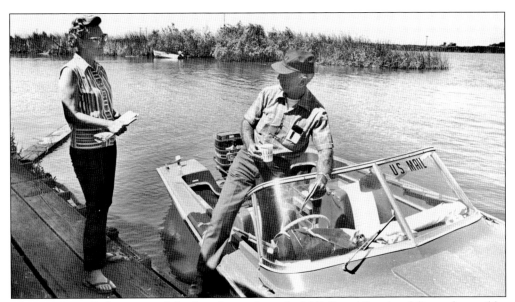

The California Delta is one of the few places where the U.S. Postal Service delivers the mail by boat. Mailboxes placed along the water edge of sloughs (pronounced "sloos") are commonplace. There are no street addresses here, only star route or rural route box numbers.

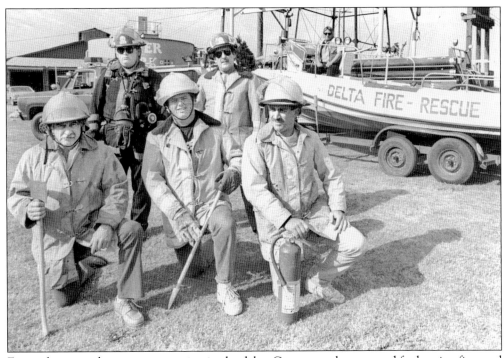

Fire and rescue takes on new meaning in the delta. Crews must be prepared for boating fires and water-related accidents, as well as for people getting lost in the tule fog. It is a paradox that, in an environment surrounded by water, peat soil burns. Once it catches fire, peat land is difficult to extinguish and can burn for months.

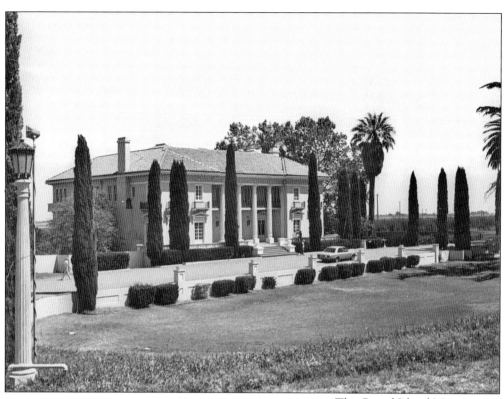

The Grand Island Mansion is a Renaissance-style home designed by architect J. W. Dolliver in 1917 for Louis Meyer and his wife, Audrey. Meyer was a native of San Francisco and a local orchardist. Meyer and his wife entertained society in their four-story, 58-room villa. It is now a private membership club

This old school, which once served Bird Island students, was moved and renovated. It is now a beautiful waterside residence in Montezuma Slough.

Six

FLOODS AND FRAGILITY

Levee failures and flooding are still a part of California Delta life, although they are perhaps less frequent than they were in the past. The threat of flooding is always with the people who farm and recreate in this great area. Delta people have just learned to live with it.

A delicate balance is required to export quality water from the delta while also making adequate quantities of good irrigation water available to local farmers and maintaining a good fishery. Around 1977, the state came up with the idea of the Peripheral Canal. This controversial 42-mile "ditch" would have taken water from the Sacramento River at the hamlet of Hood, directed it around the periphery of the delta (releasing a few trickles at selected places along the way), and then delivered most of it to the export pumps in the south delta. Even though the canal proposal contained guarantees that water quality and quantity in the delta would be maintained, most local farmers did not trust it. They opposed the Peripheral Canal, perhaps because they were uncomfortable with the fact that the canal would have been capable of diverting 88 percent of the Sacramento River's water. It was rejected by the voters of the state in 1982.

The people who proposed the canal thought it would be a shoo-in. They were digging their ditch before the voters ever said nay. The state dug 13 burrow pits along the exact route of the canal and in the exact dimensions of the canal to provide fill dirt for the construction of Interstate 5. The pits soon filled with water, and the state declared five of them located near Highway 12 to be a wildlife area, stocking the ponds with fish. Another of the ponds, located just north of Locke, was leased to a waterskiing school. The River City Water Ski Club leased a smaller pond farther to the north. Other delta structures, including the Montezuma Slough Salinity Gates near Collinsville, the Delta Cross Channel gates near Walnut Grove and Locke, and "temporary" rock barriers across waterways in the south delta, are reminders of how tough it is let others enjoy the benefits of delta water and still keep enough of it for local use.

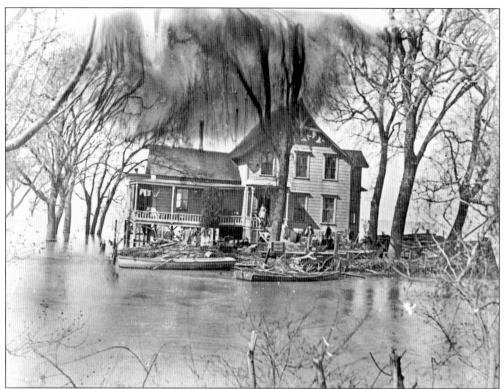

An early home on the delta is threatened by flood. There is a reason that delta homes are two and three stories tall and that a rowing skiff is always kept nearby. The Sacramento delta flooded every year during the 19th century and the first part of the 20th century. Only with reclamation, flood control, and the building of the Shasta Dam has seasonal flooding been stemmed.

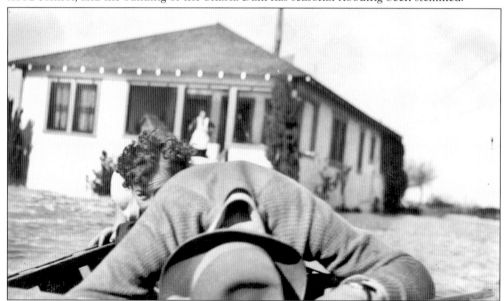

"Don't worry Mama, we'll save you!" The Colombo boys rest on their oars as the photographer takes a photograph of the waiting flood victim at their home just outside of Rio Vista.

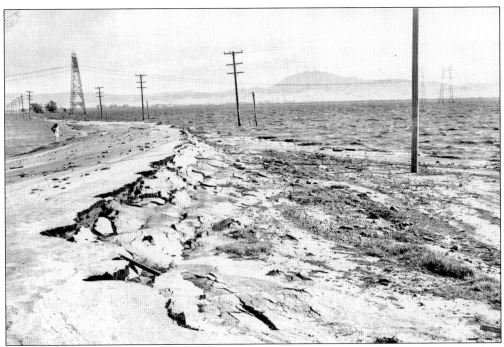

A perimeter levee road crumbles after the water has receded on Sherman Island. The water does not recede naturally but returns to the river after the levee is repaired and the floodwater is pumped out. The levee berm seen here has been washed away and undermined. Mount Diablo can be seen in the distance.

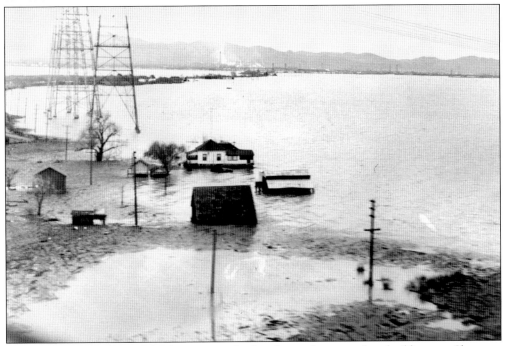

The incoming floodwaters slowly consume the farmhouse, barns, and outbuildings on Sherman Island. The Antioch Bridge and the Mount Diablo foothills are in the distance.

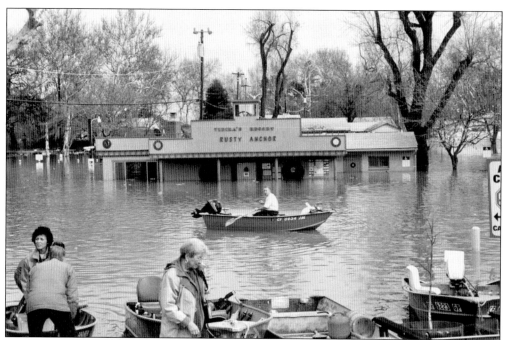

This image depicts Vierra's Resort Restaurant, located between Rio Vista and Isleton, during a flood. Automobiles are below the water level. In the delta, aluminum boats severed as a second vehicle for just these emergencies.

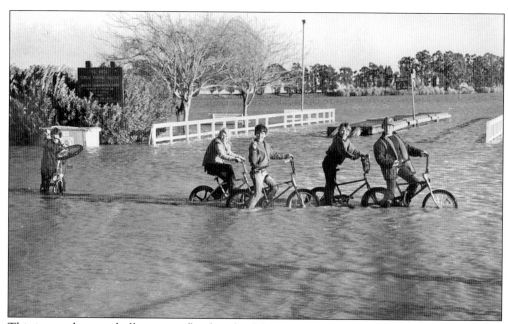

This image shows a shallow-water flood at the fishing access behind Rio Vista City Hall in the late 1970s. Note the children on bicycles. Nothing stops this group from an adventure and a good time

This is another image of Vierra's Resort flooding. Note the two men seeking safety in the aluminum boat (above). Pets are also rescued during the flood (below).

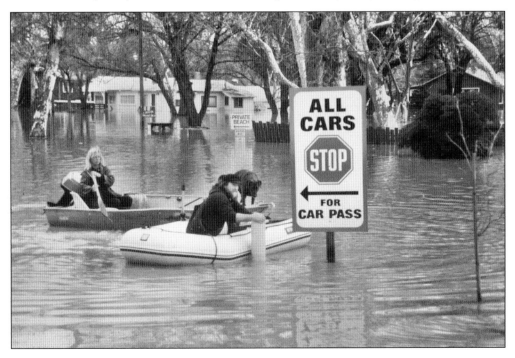

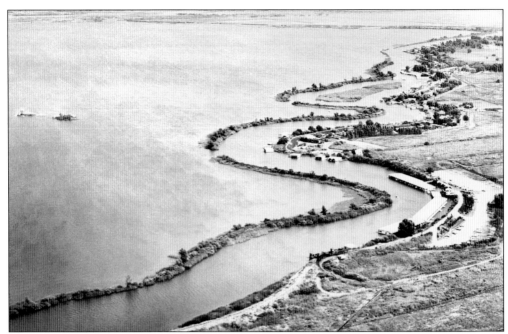

This aerial view shows the breach in the levee and the resulting flooded island. The water on the left half of the image is the flood. The cut in the levee can be seen to the left of the marina sheds. Only a water tower and a clump of trees on high ground have avoided the water.

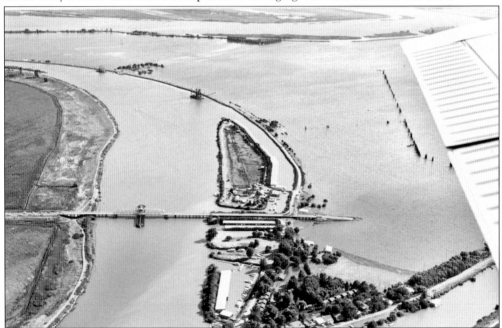

This image shows the Mokelumne River flooding in 1972 at its confluence with the Sacramento River near Perry's Yacht Harbor. The bridge fails to span the water and terminates in the flood. In the distance, dredgers are en route to attempt to minimize the gap. It may be weeks before the water finds its own level. Then the massive effort will begin to fill the gap and begin pumping the island dry, which could take months or years.

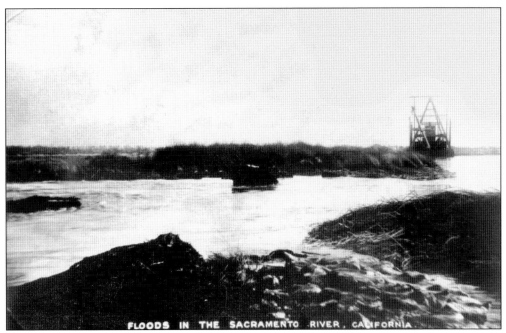

This image shows a levee break in progress. The culprit may be high tides, high snow runoff from upriver, water-saturated soil, aging levee materials, small animals burrowing in the levee, or a dozen other compounding problems. The dredger stands back so as not to be pulled into the break.

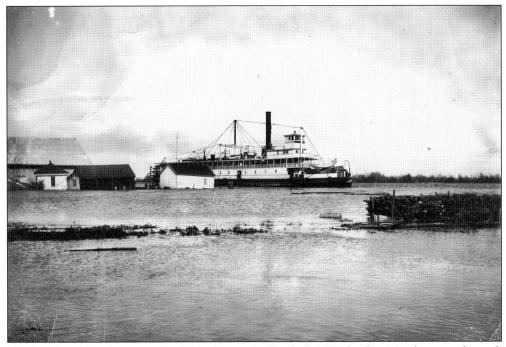

The ferry boat *Apache* stops in Rio Vista during the flood of 1907. The ship is in the main channel, but it is hard to tell. The entire town is underwater.

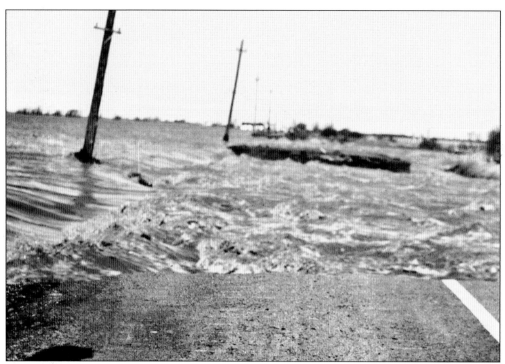

In this image, a levee break is in progress. Water is breaking through and swallowing the perimeter levee road.

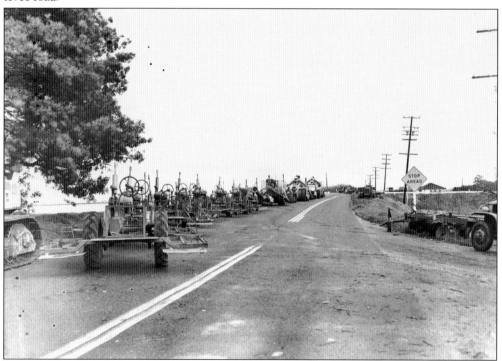

The levee road is the highest ground to be found. Here a farmer moves his equipment and tractors to the perceived safety of the road in an attempt to save his assets.

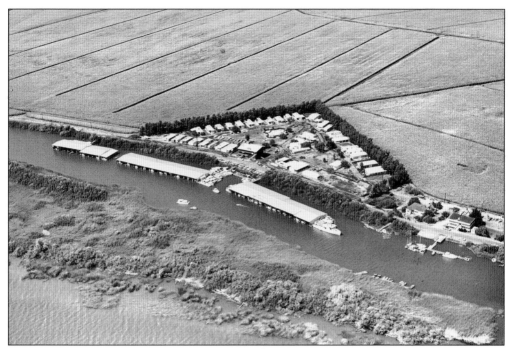

This is an aerial photograph of the Spindrift Marina before the 1972 levee break. A mobile home park is located behind the boat sheds and on the land behind the levee. Trees form a windbreak to protect the homes. Miles of grain grow beyond.

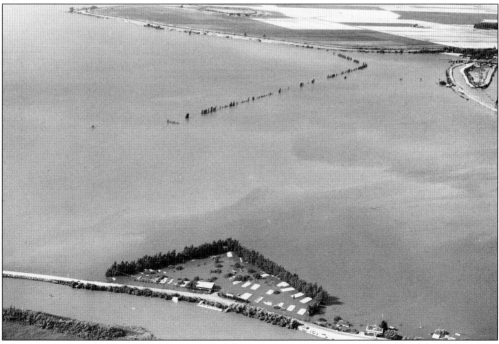

This is an aerial photograph of the Spindrift Marina after the flood and levee break of 1972. The boat sheds have been washed away. The mobile homes have been destroyed but were kept from floating away by the trees. The grain crop is under inches, if not feet, of mud.

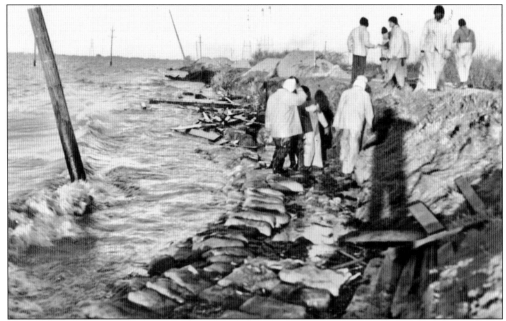

Rescue workers make a valiant but futile effort to sandbag the levee along Sherman Island. This is a close-up look at desperate last-minute efforts to deter high water from breaking through. It did not work.

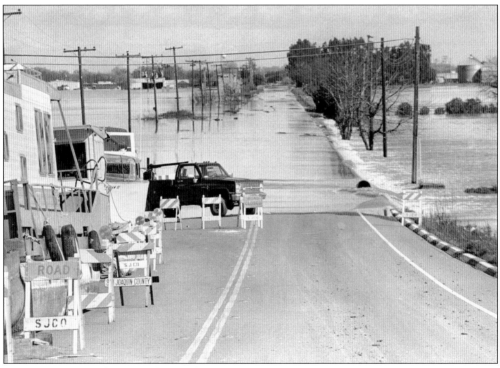

It was too late for Sherman Island. The road is closed in this image. The Sherman Island flood is now used as a model to help anticipate the effects of high water, high tides, and strong winds on levees.

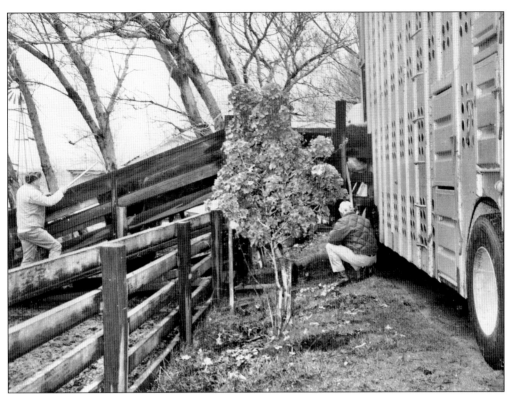

Cattlemen work quickly to round up cattle and herd them onto trucks as the water rises. This cattleman is lucky. He has not had to swim after any intransigent cows standing on a high clump of ground, bawling for help but afraid to swim to safety.

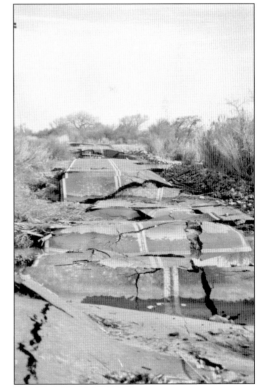

Do not attempt to drive out this way. The bucked road is along the levee, and its condition suggests that the entire berm needs significant repair before another road can be constructed along the top. Traffic on the roads is a source of wear on the levee.

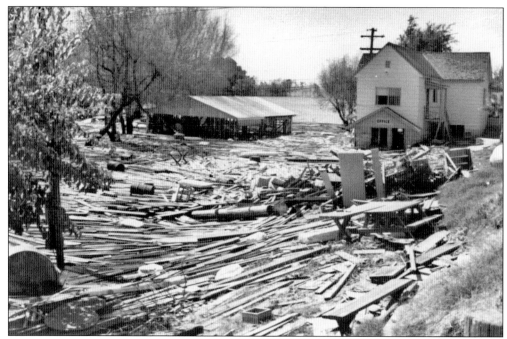

The Isleton flood that occurred during the 1970s brought all of the flotsam and jetsam of damaged buildings and wrecked lives swirling into the city. When the water receded, the town looked like a combination junkyard and lumberyard.

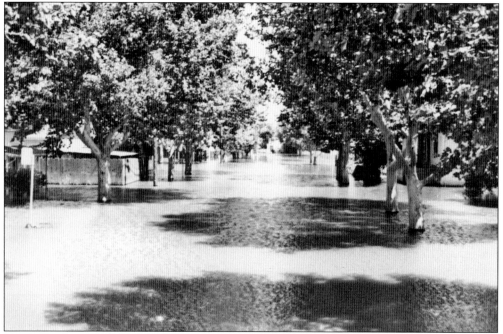

Shown is a beautiful Isleton street that was inundated during the 1970s flood. Some trees are weakened, having been rooted in ground inundated by floodwaters. Others, including those in the orchards, have fallen due to high winds in conjunction with high tides. As if the flood was not bad enough, the winds compounded the damage.

84

Seven

AGRICULTURE AND INDUSTRY

Farming the California Delta islands never seemed easy, even when the levees held and there was enough irrigation water. Farmers must have felt a great sense of isolation, especially before there were ferries and, later, bridges to facilitate travel. Getting the harvest to market was quite a challenge. Corn was dried in big cribs up on the levees and then hauled off by barges. Many of the other crops left on fleets of "mosquito boats," small vessels that took the crops to where they could be loaded onto steamboats or railcars.

Just getting around also proved difficult. The wagon trails were muddy mires during the rainy season. Kids most often walked to school, crossing modest waterways aboard rowboats that were stashed at convenient sites. The mosquitoes were especially testy in those days, darkening the delta skies.

An early primary crop was wheat, which was shipped to Port Costa and placed in the holds of sailing ships for export. Corn, alfalfa, and safflowers have long been delta crops, as well as pears and figs. Farmers change their crops for various reasons, often based on the earnings per acre that a particular crop could generate. Many acres were once devoted to celery, but little or none grows in the delta now. Asparagus used to grow on Grizzly Island, Jersey Island, and in the Isleton area, but now it is mostly grown in San Joaquin County. Potatoes were once a major crop, but they are far less popular now, partly because the practice of shipping delta water south made it easier for farmers to the south to get their potatoes to market earlier than delta farmers could. Sugar beets were long a delta staple, but as the delta water and soil got saltier, the sugar beets became less tolerant. Tomatoes are a big crop; during harvest season, the highways are busy with 18-wheelers hauling loads of them. More wineries are cropping up in the delta, and more acreage is being devoted to vineyards. Many delta wines are earning fine reputations. At least three farms in the delta are growing and marketing sod. Rice grows here, too, especially upstream on the Sacramento River. Some watermelons, pumpkins, and onions are grown in the delta, as well. Almost anything will grow in the rich delta peat soil.

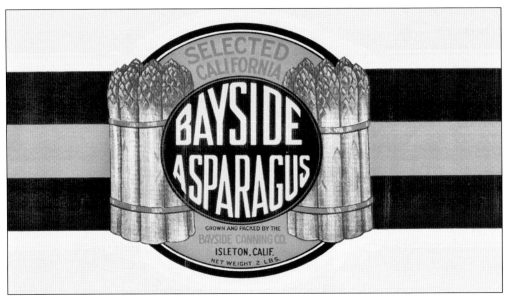

Growing and packing asparagus was once the mainstay of the community of Isleton. In the late 1920s, the town was home to five packing canneries and the largest number of seasonal employers in the delta. Three more canneries were located just outside Ryde and Rio Vista. Over 400 people (below) were employed at peak season, and 300,000 to 400,000 cases of asparagus were packed and shipped from the Sun Garden plant alone. The canneries included National Cannery, Sun Garden, Heinz Pickle, Libby McNeil, Del Monte, Patt Low, and Golden State. Bayside Asparagus (above) was one of several private labels packed and shipped from these canneries. Produce from these packinghouses found its way into many of the major grocery outlets in the United States. It was also exported to Europe, Asia, and Africa.

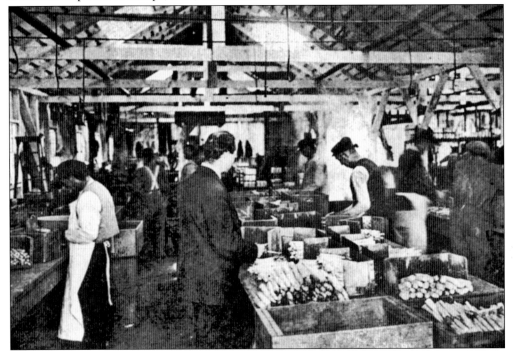

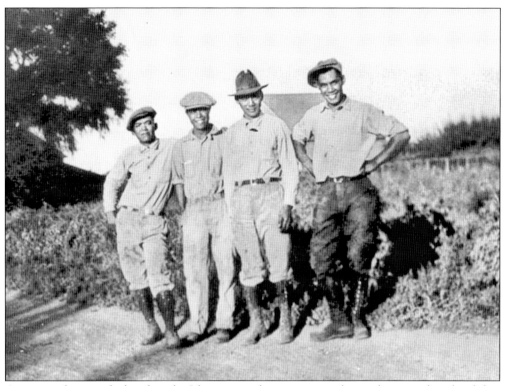

Asparagus farming declined in the Isleton area, due in part to saline infusion and to the ability of large canneries to control prices. The key to the continued viability of small farms were the inventions of the Chong brothers, Jue, Sam, Bing, and Look, pictured above. When asparagus plants become old and unproductive, they must be uprooted to make way for other crops. Jue Chong, in partnership with his friend, Joe Miller, developed an asparagus plow (below) designed to rid the land of roots and prepare the property for new crops. Seven patents were issued for the blade design and the plow machinery.

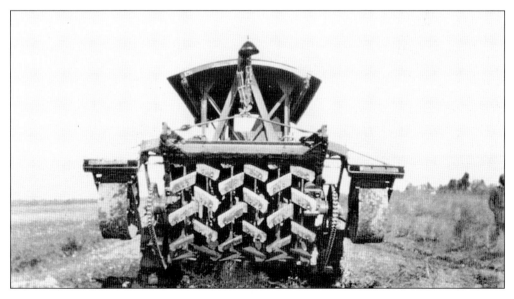

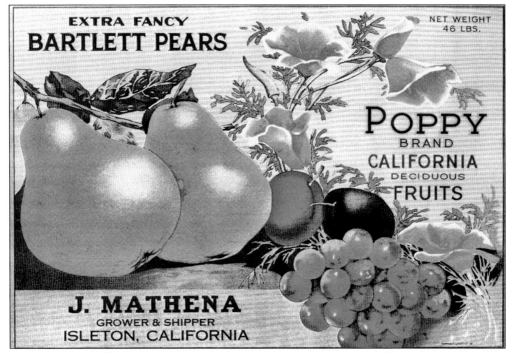

The delta has produced delicious Bartlett pears for over 100 years. Fruit box labels such as this one are highly collectable for their colorful graphic art.

Visitors driving along the delta can still see small, 40-acre pear orchards along the levee road. The trees are often "buzz topped" to limit their height and force nutrients into the fruit instead of new growth. In contrast to the practices of many modern apple orchards, Bartlett pears are still picked by hand using ladders and are individually packed for fancy grade.

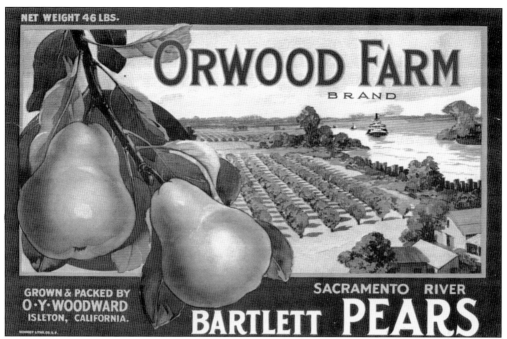

NET WEIGHT 46 LBS.

ORWOOD FARM
BRAND

GROWN & PACKED BY
O·Y·WOODWARD
ISLETON, CALIFORNIA.

SACRAMENTO RIVER

BARTLETT PEARS

Many delta visitors know the Orwood tract for its recreational boating, swimming, and fishing. Its original fame came from its orchards and other agricultural endeavors. The Santa Fe Railroad built a spur from Banta to Port Chicago to move the area's produce to market.

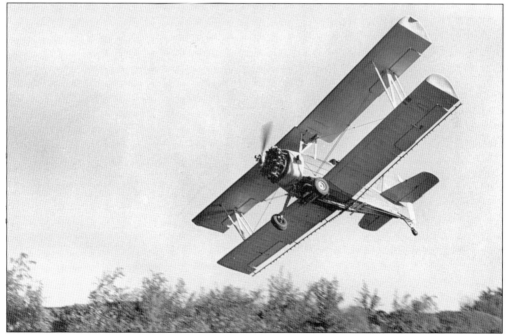

With bounty come pests. The use of airplanes to apply pesticides over large tracts of land came into practice in the delta right after World War I. These relatively slow-moving airplanes can carry large, heavy loads of water-based fungicides or pesticides for application to the orchards. Most crop dusting occurs in the early morning, when there is little wind, to allow for precise application.

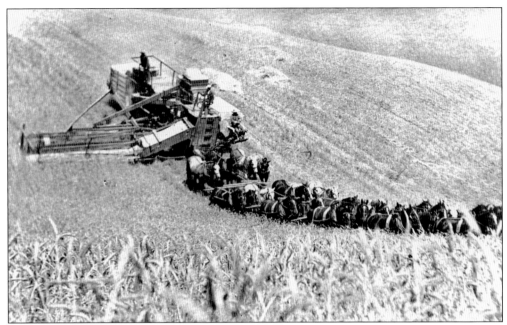

Sowing, raising, and harvesting wheat was one of the earliest agricultural practices in the delta. Pioneer John Marsh is credited with introducing wheat and other grains to the San Joaquin Valley on his Rancho Los Meganos in 1837. In this image, a combine pulled by 24 horses, harnessed four abreast, harvests wheat on the Statton Ranch in Birds Landing.

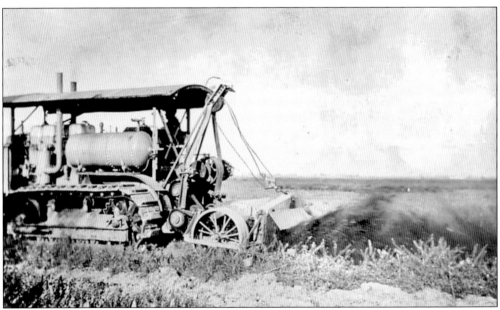

The Chong brothers' asparagus ripper is in action here, pulled by another delta invention, the caterpillar track engine, manufactured by the Holt Company of Stockton. Delta lands are soft peat lands, in which traditional narrow-width wheels easily sink and become mired. Peat dirt is soft, alluvial, and flies like fine, light dust. These attributes are the secrets to the delta's farming success.

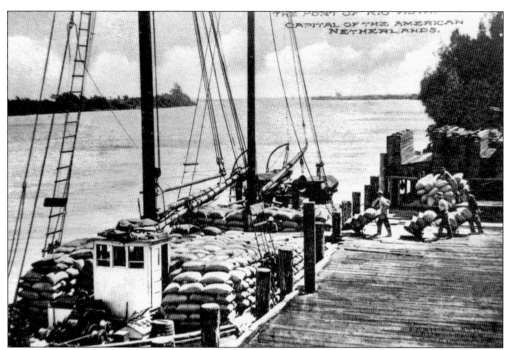

Just about everything grows, and grows abundantly, in the delta. From the beginning, crops were grown for export, not for local subsistence. Men in the gold fields and silver mines toiled for minerals with no time or interest in farming. Delta agriculture responded by producing commodities. Each farmer raised a specialty crop: onions, potatoes, beans, grain, fruits, nuts, sugar beets, and hops. Transporting a large volume of crops quickly and inexpensively was the job of the fleet of shallow-draft potato barges (above) that traveled up the sloughs to the loading docks. From there, produce was floated upstream to Sacramento to sell in the mining communities or was sent downstream to San Francisco for transshipment to Europe. Seen here is the *Pioneer* (the second ship of that name), a 100-foot craft built in 1867. She had a short life of 10 years hauling produce. Alongside her is the barge *Philip* (right).

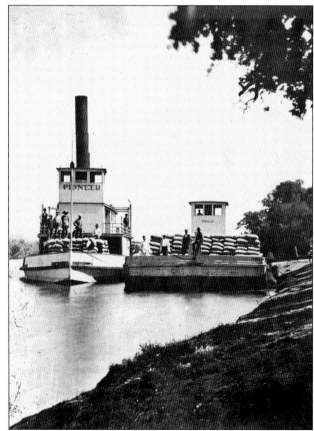

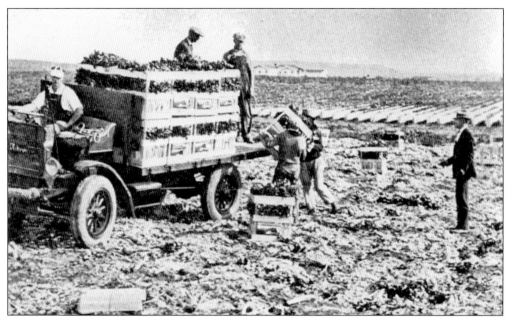

Crates of celery are loaded in the fields at Terminus around 1930. Next they will be taken to packing sheds for trimming, washing, and crating, then loaded onto Western Pacific railcars for shipment to market. Growing celery is very labor intensive. It is no longer grown in the delta.

Along the levee road is the automotive equivalent to a potato barge. This one is indeed carrying a load of potatoes from Bacon Island. On the other side of the berm is the slough. Crops are grown right to the edge of dry land. This vehicle had no license plate because it spent its entire life on private island roads.

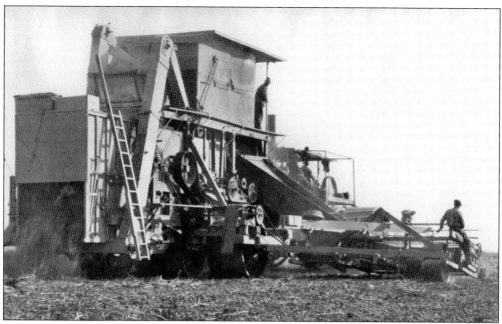

The invention of the first bean harvester (above) was made necessary by the massive agricultural output of the delta. Inventiveness is required to harvest crops that are quickly maturing. In this case, the cost of inventing the bean harvester nearly bankrupted its inventor. A mechanical harvester can harvest over 100 acres of beans in day, a task that would be impossible to accomplish with only manual labor. Below the 13 men of the Ryer Island harvester crew pose for the camera with their dog.

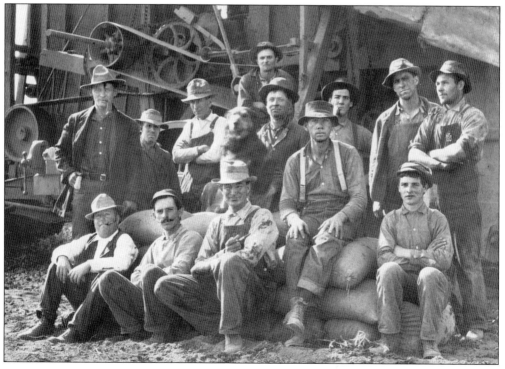

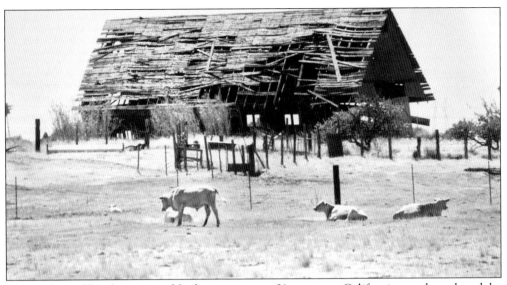

The traditional hay barn is quickly disappearing in 21st-century California, much as the adobe building disappeared in the 20th century. Take time to appreciate this picturesque reminder of early California agricultural history now before it deteriorates in front of your eyes. This barn on Bethel Island reminds us of the substantial herds of cattle that once grazed here.

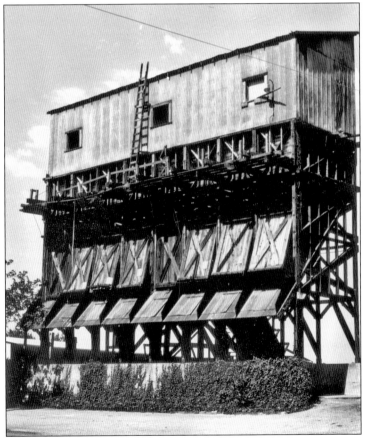

This grain elevator is used for storing and shipping large volumes of grain, which were transported on barges or container ships. Gone are the individual sacks of grain. Deep-draft, ocean-going ships travel up the Sacramento River and take on huge loads. Down these chutes flow grain to feed the world. Agriculture is still California's largest source of income, fueling the fifth-largest economy in the world.

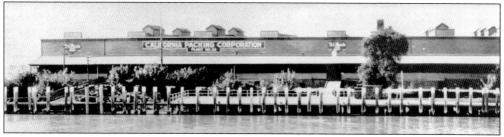

Before the advent of the automobile, Southern Pacific and its affiliates controlled all railroad and water transportation in the delta. They did their best to control agricultural prices by expanding into the packing market: their subsidiary, the Del Monte Corporation, acquired plant 22 of the California Packing Corporation, which was located just outside of Rio Vista.

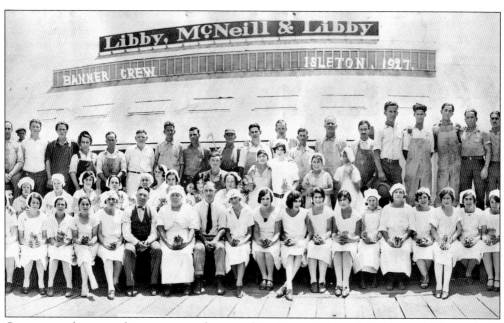

Cannery workers pose for a company photograph in front of Libbey, McNeil and Libbey in 1924. Canneries operated 24 hours a day in three shifts during harvest season. Libbey packed fresh produce in addition to canning vegetables. Note the mixed ages, genders, and nationalities of the workers; some are local residents and some are migrants.

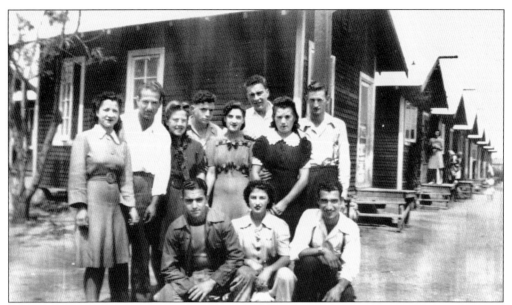

Migrant workers often moved with the seasons of the crops. While mother and father worked in the fields or the packing plants, the kids went to school. During the first half of the 20th century, older children often worked alongside their parents. In those days, there were no labor laws precluding minors from working in the fields or packing plants.

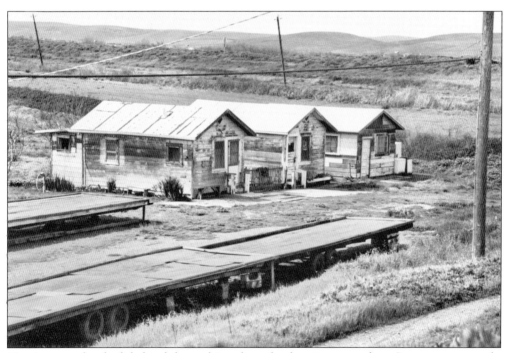

Housing was often built behind the packing plants for the migrant workers. It was not very posh. During harvest season, plants operated day and night. With the workers close by, plants never had to shut down, and there was no waiting for the workers to arrive. These houses were on Sherman Island.

Eight

FISHING FOR FUN AND LIVELIHOOD

Commercial salmon fishing began in the Sacramento River in the mid-1850s, shortly after the Gold Rush. By the 1880s, the industry occupied some 3,000 people and 1,200 boats, reaching from San Francisco up to Sacramento and on to Stockton. The average annual salmon catch was six million pounds of fish. A small boat crewed by two men could gill net over 700 pounds of salmon on a good day. Salmon sold for as much as $1 per pound. Silt from placer mining and giant water projects resulted in the end of commercial salmon fishing in the delta.

By 1934, salmon canning was no longer allowed in delta waters. Only fresh or frozen salmon could be sold. By 1958, the annual commercial salmon catch had dwindled to 400,000 pounds, and commercial fishing for salmon was banned. Fishing for striped bass was introduced in 1879, and within 10 years provided a substantial commercial fishing industry, replacing salmon as the number one commercial catch. Commercial fishing for striped bass continued until 1934, when it was banned.

Other species of fish that provided commercial catches included sturgeon, American shad, and catfish. By 1957, all net fishing in the delta had been banned, and the colorful commercial fishing era was over. However, commercial trapping of crayfish (crawdads) began in the delta in 1970 and continues to this day.

Sport fishing for salmon, striped bass, largemouth bass, sturgeon, American shad, catfish, steelhead, and other species of fish continues in the delta. The salmon fishery has greatly improved in recent years. Most largemouth bass anglers practice catch-and-release. Sturgeon less than 44 inches long and over 72 inches may not be kept. Sturgeon derbies, striped bass derbies, and largemouth bass tournaments are popular activities in the delta. The sportfishing industry has replaced the commercial fishing industry.

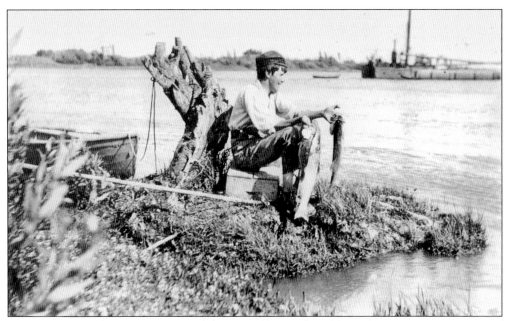

The young Howard Lauritzen poses with his striped bass and catfish catch in a scene reminiscent of Huckleberry Finn on the Mississippi River. This fantasy is not so far-fetched: all four film versions of Mark Twain's classic were filmed here in 1919, 1931, 1939, and 1961, respectively.

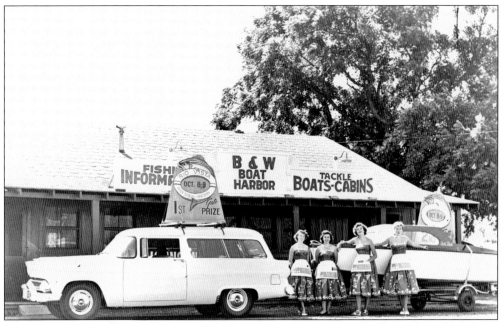

The first stop on any delta fishing trip is the bait shop, where one can find out where the fish are biting and pick up some gear. This 1955 Rio Vista Bass Derby promotional photograph, taken in front of the B&W Boat Harbor shop, features four waitresses in matching dresses and aprons.

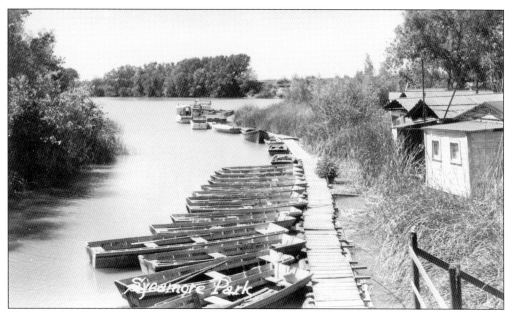

The next stop is to rent a boat here at Sycamore Park. From the 1940s through the 1960s, many people owned a motor and rented a boat at a cost ranging from $5 to $20 a day. Early outboard motors were two-cycle engines that burned a polluting combination of oil and gasoline.

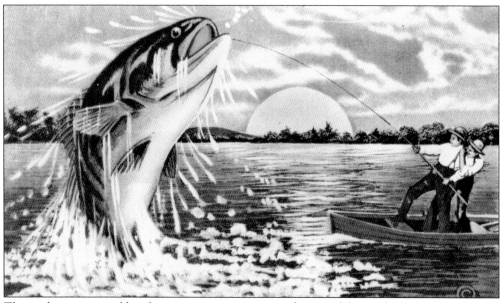

This early promotional brochure appears to exaggerate the size of the catch. Perhaps the illusion is only due to the modest fishing gear used to bring in this championship-sized fish, which was caught in the delta. Some of the largest stripped bass, black bass, and sturgeon caught in the United States have been pulled from these waters.

Delta Area Fishing:

LARGEMOUTH BASS - Largest of the black basses, which includes the smallmouth. Likes shallow, murky waters & hangs around structures, weeds or submerged timber. The world record is 22+ pounds. Largemouth bait includes juicy worms, powerbait & lures.

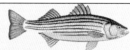

STRIPED BASS - Stripers are often regarded as the prize fish of the Delta. Voracious stripers live almost everywhere in the Delta waterways. A record 67 pounder caught in 1942 is displayed in Del's Boat Harbor. 18" + are keepers. They hit on threadfin shad, sardines and anchovies.

BLACK CRAPPIE - Suited best for clear water and small impoundments. Popular sportfish that some say is the tastiest. The world record is 6 pounds, but most are much smaller. Black Crappies go for rubber lures, mini jigs, and worms, but flies and poppers work after dusk.

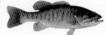

SMALLMOUTH BASS - Hard-fighting sportfish prefers deep water and rocky areas. World record is nearly 12 pounds, but they are usually under two pounds. Worms, fish strips and lures all work well.

BLUEGILL - One of the most commonly caught panfish in America, the bluegill often provides kids with their first fishing thrill. It's not big, but it is a scrappy fighter, & it's saucer shape makes it hard to reel in. Most bluegill are caught when they move to shallow water to dish out a bed for spawning. Most often this tasty little fish is caught on worms and jigs.

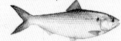

AMERICAN SHAD - Not to be confused with the tiny threadfin shad, which is a good baitfish, this anhydrominous species leaves the Delta as a juvenile, and then returns later to make a good catch for a lucky fisherman in the brief season of April and May. The Mokelumne River above New Hope Landing & the Sac River are good bets.

THREADFIN SHAD - This tiny herring schools in vast numbers and is the mainstay of many Delta gamefish diets. They endlessly migrate to feed.

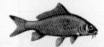

CARP - The most unpopular fish for American fishermen is very popular for Asians and Europeans. Carp catching is done on concoctions of bread dough, jelly beans and all kinds of stuff for bait. The world record is 83 pounds, but the California Delta record is unknown.

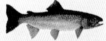

STEELHEAD - This fish is also called the Rainbow Trout, and is amongst the best eating in the fish kingdom. In salt water its color is dark, steel blue to gray. They arrive from the ocean in early Fall, and head back to sea in December or January. Caught on lures, flies, worms, ghost shrimp, crawfish tails, or stripbait in the Delta's brown waters.

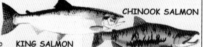

CHINOOK SALMON

KING SALMON

SALMON - With the human population, fish screens, water diversions, etc., the Chinook has become an endangered species in California. However, the King Salmon is still an often sought gamefish in the Delta, especially in the Sacramento River below Sacramento and upstream. The Mokelumne River & American River have excellent, replenishing salmon fisheries.

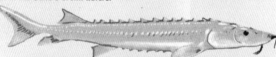

STURGEON - White sturgeons have historically been caught at over 1000 pounds, with greens (like this one) at 350 pounds. Must be over 46", but under 60" in length. Caught on ghost shrimp, eel, threadfin shad, crayfish or other baits. Sturgeon are usually caught in deep holes on the Sacramento River, Rio Vista, Suisun Bay, Carquinez Straight, etc. Season is all year, bag limit is one.

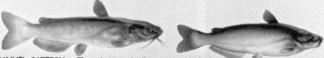

CHANNEL CATFISH - These bottom dwellers are overlooked by a lot of anglers casting for other favorites, but a delicious channel cat is never far away. The world record is 58 pounds. They are caught on Delta clams, chicken livers, anchovies, angle worms, fish flesh strips and all kinds of secret bait concoctions.

CRAWDADS - Also called Crayfish, these guys can be trapped using any cheap dog food for bait. Good crawdads are a delicacy that every fisherman should get a taste of. They hibernate, so catch them when the water is warm. There is no catch limit.

BLUE CATFISH - Looks like the channel catfish, but has bluehue and humped back, a longer anal fin and gets bigger. Bluesdon't go for bait concoctions, but will take crustaceans or cut fish. World record is 109 pounds, but Delta record is unknown.

At least 14 species of fish are commonly found in delta waters, including flounder, sunfish, and some recently introduced (and not necessarily welcome) species. It is a sportsman's paradise.

White sturgeon is found commonly at the western extreme of the delta in Suisun Bay, where Ras Jensen caught this "small" specimen in 1962. The U.S. Navy's mothball fleet of ships provides the primary delta habitat for this prehistoric fish. Sturgeon love shrimp and are basic bottom feeders. The eggs, when processed, make delicious caviar.

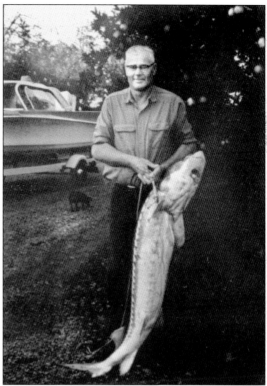

The delta promotional brochures are true! This striped bass, held over the shoulder of a bass tournament participant, confirms their claims.

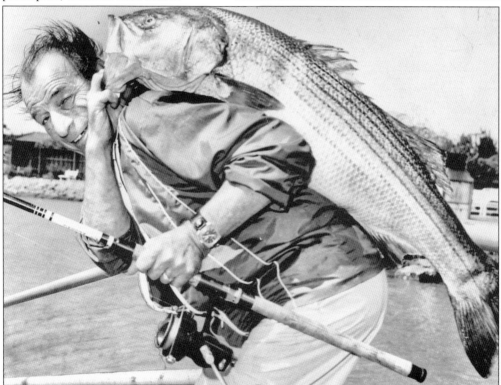

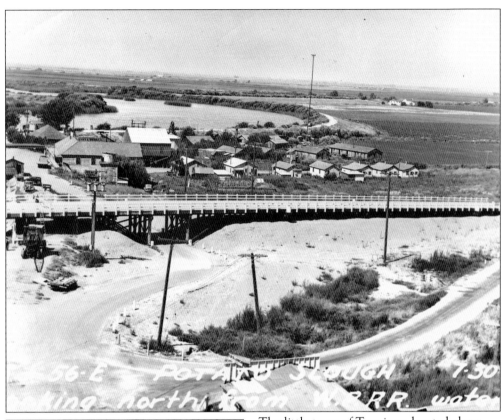

The little town of Terminus, located along Potato Slough, is pictured here in 1930. Terminus later became a ghost town. It was revitalized as a major marina and houseboating center in the 1980s.

This is the largest largemouth bass caught in the California Delta, reeled in by avid tournament angler Galen Jensen in February 2002. Weighing 18.62 pounds, it was only a few ounces shy of being the largest largemouth bass ever caught in Northern California. The fish are getting bigger since the introduction of the Florida strain bass.

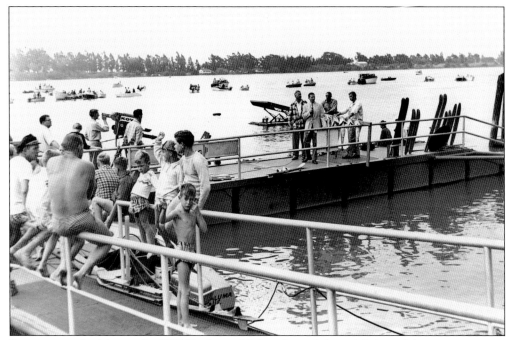

Sacramento television station KOVR, channel 3, broadcasted the weigh-in and the announcement of the winner of the 1958 Rio Vista Bass Fishing Derby to the greater Central Valley as part of its prime-time news coverage. Spectators, children, and boaters line the dock to await the news. Note the water-ski jump in the background.

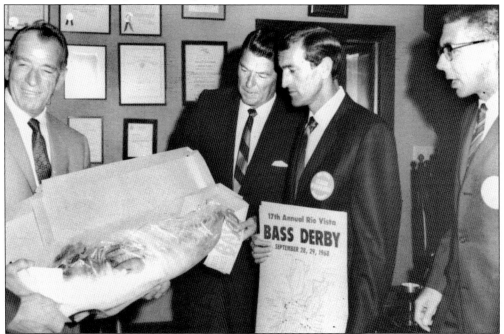

A striped bass has been presented to the governor of California each year since the Rio Vista Bass Derby and Water Carnival began in 1933. Here Gov. Ronald Regan is presented with a fish by the committee chairperson at the 17th annual derby in 1968.

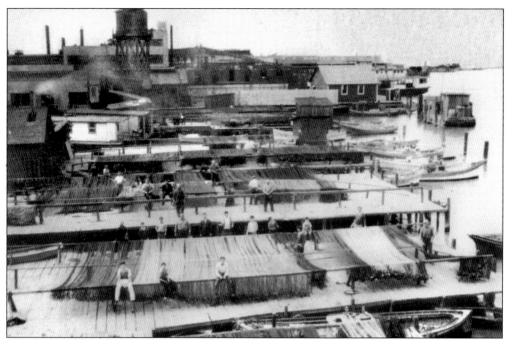

Commercial salmon fishing began in the mid-1850s, and by 1880 over 1,200 boats and 21 canneries were engaged in the industry. A typical boat in the Rio Vista area would bring in 600 to 800 pounds of fish per day. By 1934, commercial canning operations were closed by the state as the salmon population diminished.

This floating two-story barracks on Mandeville Island served as seasonal quarters for migrant workers. A tugboat could move it upstream or downstream as needed. It was destroyed by fire.

Crawfish are one of the few species still commercially trapped in the delta. Most people catch these delicious crustaceans in a baited trap overnight or try their luck off a dock with bacon and string. The Isleton Crawdad Festival, held in June, is the best place to catch these critters.

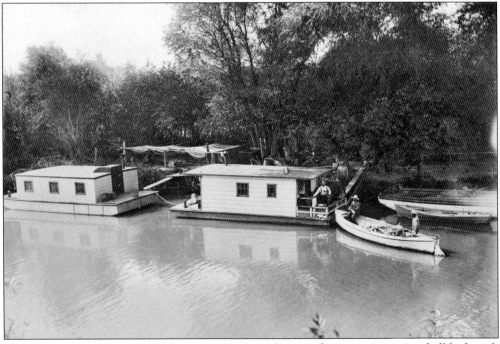

Houseboating is utilitarian and fun. Here two houseboats and an accompanying skiff find a safe harbor along the bank of Wood Island near Rio Vista. It was common for men—and sometimes whole families—to live aboard a houseboat close to the fields during busy farming days.

In 1985, a humpback whale entered San Francisco Bay (above). His travels were followed closely by the public as he swam up the Sacramento River into a freshwater habitat. The whale, affectionately named "Humphrey," was first spotted at Oakland's Outer Harbor on October 10, 1985. He swam up the Carquinez Strait to the Sacramento River and under the Rio Vista Bridge to a dead-end slough 69 miles from the ocean (below). Humphrey returned to the Pacific Ocean under the Golden Gate Bridge on November 4, 1985. A granite plaque at the Rio Vista harbor commemorates the visit, and local restaurants' menus remark on Humphrey's stay in Rio Vista. In May 2007, two humpback whales entered San Francisco Bay and swam up the Sacramento River near the Port of Sacramento in the deepwater channel, progressing further than Humphrey. After more than two weeks, they finally made it back to sea.

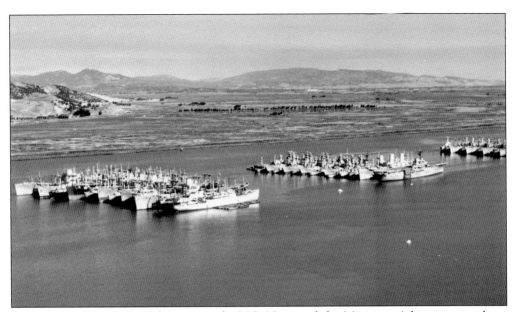

Since the middle of the 19th century, the U.S. Navy and the Maritime Administration have stored surplus vessels in the calm inland waters from Suisun Bay to Rio Vista. The fleet of World War II ships has been reduced to those moored near Vallejo (above). Today there are more than 150 obsolete ships, including Maritime Administration freight ships and navy war ships, moored in tight rows of 10 over 500 acres of Suisun Bay. The rationale for creating the mothball fleet was to maintain a supply of large ships (below) that, if necessary, could be pressed into service to bring goods and supplies to troops overseas. The number of ships in the fleet has been reduced as some ships have been used for scrap. Once anchored here were the *Jeremiah O'Brien*, the USS *Iowa*, and the *Glomar Explorer*, made famous during the cold war when it was used to recover a sunken Soviet submarine.

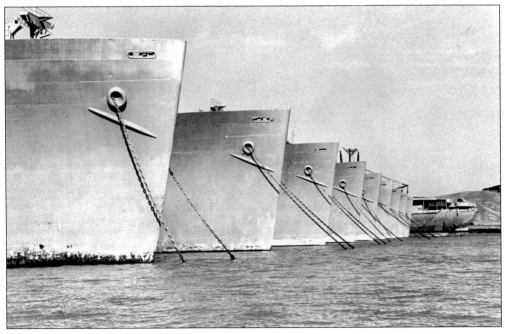

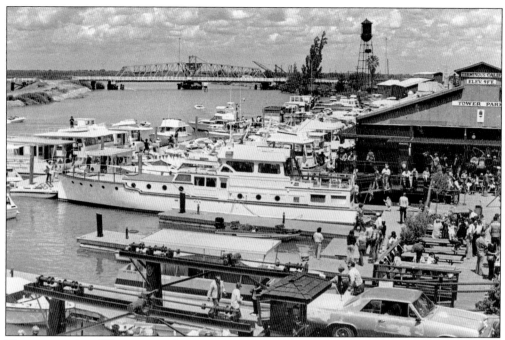

The community of Terminus and its active marina are located along California State Route 12, five miles west of Interstate 5. "Potato Slough" has come a long way; today it is a state-of-the-art marina and a launch site for cruising the delta.

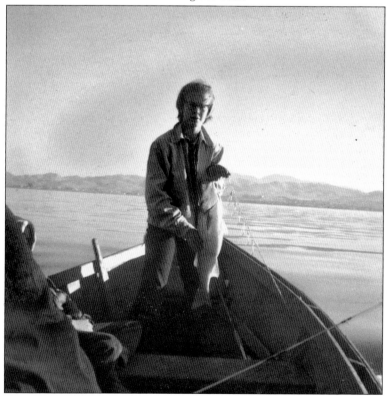

This prize striped bass was caught out of Big Break Harbor on a two-hook leader using clam bait sprinkled with a little anise flavor. This is my idea of recreation and good times! Turn the boat around for home now, Richard.

Nine

RECREATION AND GOOD TIMES

A very modest amount of recreational boating began in the California Delta in the late 1800s when Jack London came to visit. In 1902, Roy and Theodore Stephens started Stephens Marine on the Stockton Channel and built a 25-foot motor launch for a Stockton banker. But recreational boating did not gain much of a foothold until after World War II. Marinas to serve boaters and anglers hardly existed until that time. Korth's Pirates Lair Marina got its start in 1938 when Josephine and Albine Korth, while farming on Andrus Island, rented their skiff to an angler for a day for the substantial sum of one silver dollar. The Perry family had a place to rent fishing boats at Port Chicago in 1927. In 1939, the family moved to Rio Vista to establish Perry's Boat Harbor on Andrus Island.

Blanche and Jack Farrar established early recreation on Bethel Island in 1930 with a park that provided swimming, picnicking, and other activities. This later became a marina called Farrar Park. Warren Remsburg started Remsburg Harbor in 1938. By 1944, the Andronico family was expanding Frank's Fishing Resort on Bethel Island. The resort featured a party boat and large numbers of rental fishing boats.

By the 1950s, many anglers owned outboard motors and brought them along to power the fishing boats that they rented. Affordable cruisers between 24 and 28 feet long were built. Many had plywood hulls and were powered by a single inboard engine. Ownership of a yacht became a reality for middle-class Americans, and the delta was growing fast to accommodate them. Yacht clubs and boat clubs formed, and many now have over 50 years under their belts.

In 1936, Stocktonian snow skiers Ni Orsi Sr., his sister Elsie, and Holly Thorns heard that an outfit in New Jersey was marketing water skis. Skiing on the water sounded like an interesting novelty, and Ni ordered some water skis. It was not long before this trio and their friends had taught themselves to water-ski. They were probably the first water-skiers in California. Today there are over 110 marinas and waterside resorts in the greater delta region.

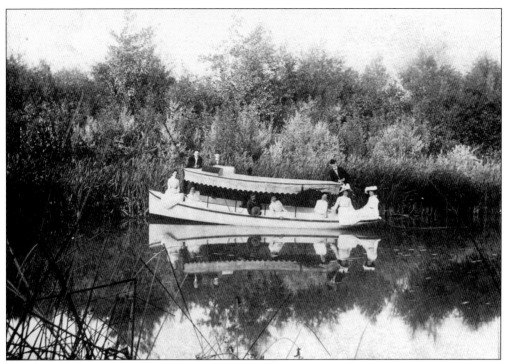

This group is enjoying a Sunday outing on the Sacramento River around 1910. Ladies and gentlemen, take a break from the dredger and enjoy an excursion and a picnic. Ladies, please wear your hats; gentlemen, ties are preferred.

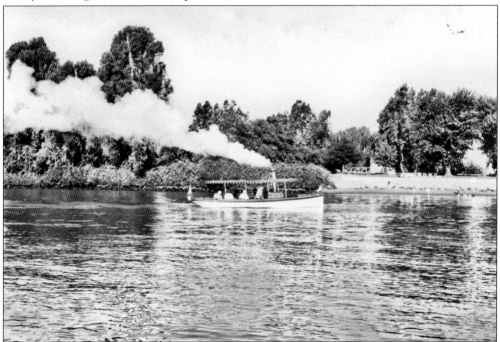

Traditional launches powered by temperamental steam engines have been saved and restored. They are great crowd-pleasers wherever they are displayed or run.

A happy wading party is seen here on Wood Island, Rio Vista, in the early 1920s. Pictured out on the limb are mostly Scandinavian pioneers of the area, including members of the Hansen, Rasmussen, and Nielsen families.

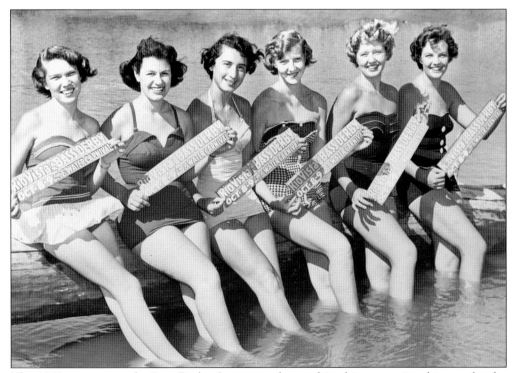

The 1955 contestants for Bass Derby Queen are featured in this promotional image for the annual Rio Vista event. The winner was Claudia Howes, second from the right, who sold the most tickets for the event.

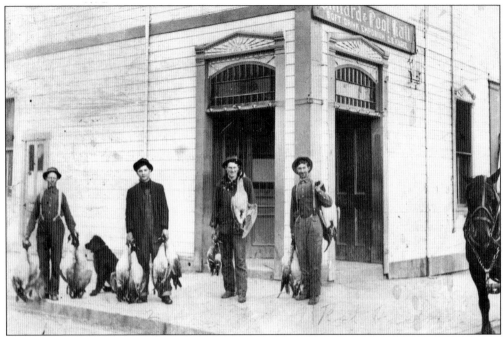

Hunting birds for food, recreation, and commercial sale is a great part of the delta experience. The marshland is on the major migratory flyway from Canada to Mexico. These successful hunters have their limit of Canadian Geese and are destined for home. They pose in front of Kagee's Billiard and Pool Hall in Rio Vista.

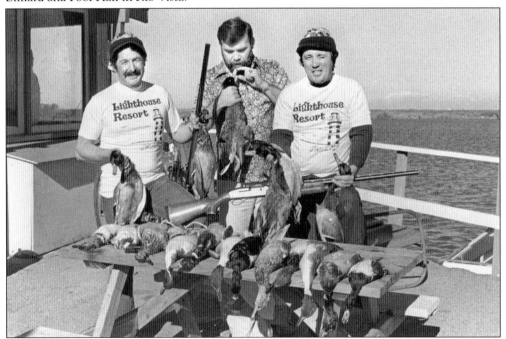

Commercial duck hunting is no longer licensed in the delta, but these recreational hunters have bagged a broad selection of ducks for the table. Rice and grain lands attract birds, and many duck blinds are hidden in the tule forest by gun clubs.

Speedboat racing is a natural sport along the calm, early morning delta waters. The racing lanes are wide and smooth.

This image features a competitive speedboat on the delta and an inset picturing the driver, Bob Lawson.

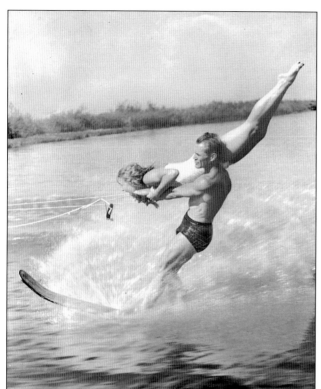

Waterskiing, including fancy water-ski tricks, have been part of the delta experience since boats could pull a man out of the water. Trick ski events like this one continue to be a featured attraction of any water carnival.

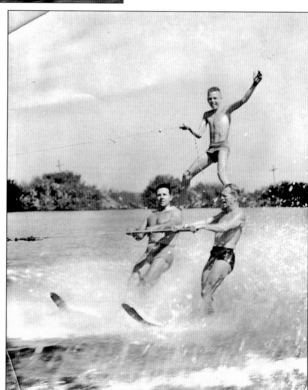

You need not go to Marine World amusement park to see fancy skiing like this three-man pyramid. Watch as they do it barefooted or on a wakeboard!

This beautiful 76-foot vessel was used in the 1976 television miniseries *Rich Man, Poor Man*, which made actor Nick Nolte a star. The ship's owners, Ray and Suzy Lennol of Discovery Bay, hoped the craft would earn its weight in diesel oil through deluxe charter service.

Sailing up the delta to Sacramento, whether in a regatta or individually, is great fun. If undertaken only under sail, the trip can take a week. The winds are always blowing in the afternoon, it seems, when the Carquinez Strait brings in a strong ocean breeze.

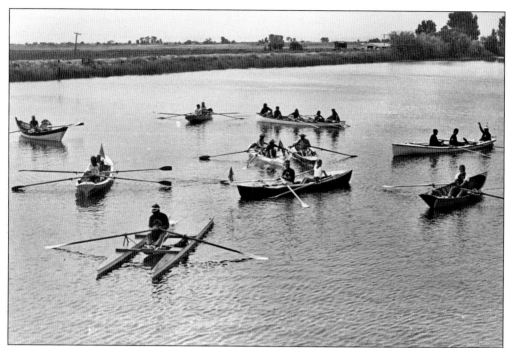

Traditional watercraft, mostly dories and some rowing shells, ply the water at a Discovery Bay regatta. They appear as so many water boatmen resting lightly on the water. Rowing has quite a following among purists and collectors.

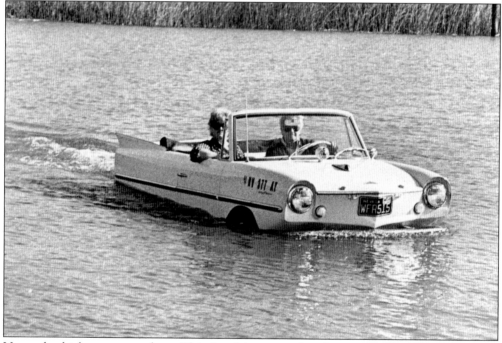

Unusual vehicles are everywhere. This Amphicar, owned at the time by Hap Sosso of Walnut Grove, was manufactured by a German concern from 1962 to 1964. It is a true amphibian, powered by a Triumph Spitfire engine capable of 80 miles per hour on land and 11 knots on water.

Traditional craft may have their following, but most delta people enjoy their power craft. There is nothing like a cruise with your dog on a bright sunny day. Yes, this is "where the boys are."

And this is the reason why the boys are here. There is always a homegrown beauty show wherever good times are had and good people get together. There is always a crowd at Lost Isle resort.

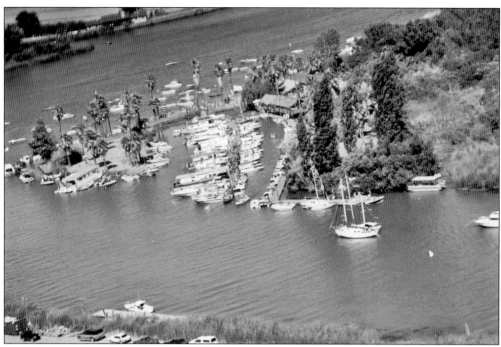

One of the favorite boat-access-only resorts on the delta is Lost Isle. A typical Fourth of July weekend will find boats of all descriptions five or six abreast and patrons at the bar equally deep.

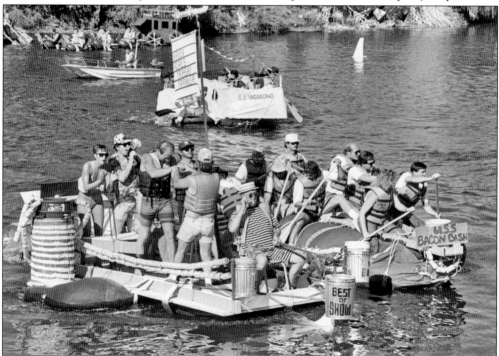

Water carnivals and raft races are part of every boating season's opening-day celebration. Each craft may have a theme, or organized mayhem may be preferred. Bathtub races at Bethel Island have long been a favorite activity. Here sea horses pull a stagecoach in the background.

Hot air ballooning is a recent attraction and recreational interest. In the serenity of the morning, one can float over the water in complete stillness. Schools of fish can be spotted, and it may even be possible to catch skinny-dippers unaware in their private water holes.

Ski-kiting and parasailing are a lot of fun. Once aloft, you may see the remains of a century-old ferry hidden over the levee or an abandoned cabin cruiser tucked away in the tule grass. And take time to stop by the Pirate's Lair.

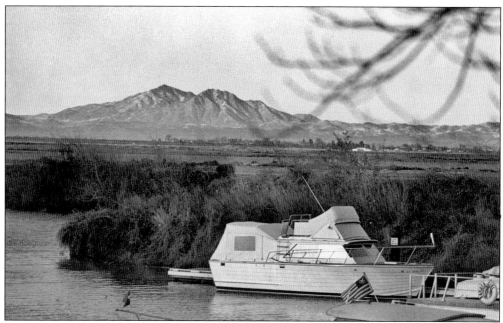

"Believe me, my young friend, there is NOTHING—absolute nothing—half so much worth doing as simply messing about in boats. Simply messing," remarks Ratty to Mole in *The Wind in the Willows*. Author Kenneth Grahame could have been writing about the boating life along the Sacramento and San Joaquin Rivers. Here we find bucolic days, welcome anchorages, and friendly people just an hour from the urban areas of San Francisco Bay.

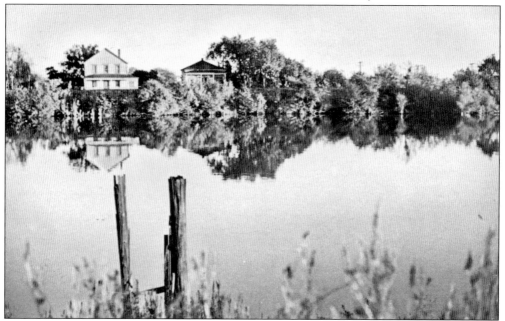

What we all want is tranquility and a place on the river at the end of the day. This image looks from Grand Island to the pilings of the old Vollman docks on the Sacramento River. Pictured is the former home of Alexander Brown, founder of the Bank of Alex Brown. If you were a Brown, you would be home now.

Ten

LIFE IN THE DELTA

Life in many of the river towns of the California Delta has changed little in the last 100 years. Byron, Rio Vista, Isleton, Ryde, Walnut Grove, Locke, Courtland, Hood, Clarksburg, and Freeport are still sleepy communities. Some delta towns have disappeared, or nearly have, including Collinsville, Birds Landing, Holt, and Emmaton. A few have blossomed, such as Oakley, Brentwood, and Discovery Bay. Brentwood was named the fastest-growing community in California by the California Board of Realtors in 2005. Discovery Bay is young at heart but has a classic lifestyle.

The delta is a place to get away from it all, a place for living life in the slow lane. Even if you depart from a busy marina, in 10 minutes you can be out in the tule grass, away from civilization. Some of the major agricultural islands in the central delta may be populated by no more than a dozen souls.

You can enjoy simpler pleasures here. Take in the sounds of a thousand snow geese in residence on a delta island during their fall migrations. Watch crop dusters in their biplanes, looking like part of a World War I movie, in the early morning. Hear the sounds of a Holt tractor tilling the soil off in the distance. Wave to the River Route mail carrier making his daily deliveries by boat. And enjoy skinny-dipping in a secluded anchorage that you discovered and have all to yourself.

For most of California, the delta comes to public attention during levee breaks and water wars. The delta is more than quaint towns, bass derbies, and wakeboarding. It is a major source of drinking water for the state, as well as an important location for recreation and agriculture. The aging infrastructure, aqueducts, and levees are deteriorating rapidly. Regional climate change, floods, and earthquakes threaten disaster; the question is when, not if, disaster will strike. The man-made islands are sinking, invasive species are breeding, and flood plains are now urbanized. Delta residents are resilient and live with nature's changes, but just one major levee failure could create a domino effect, impacting California's drinking water, irrigation systems, and overall lifestyle. Heed the call to action!

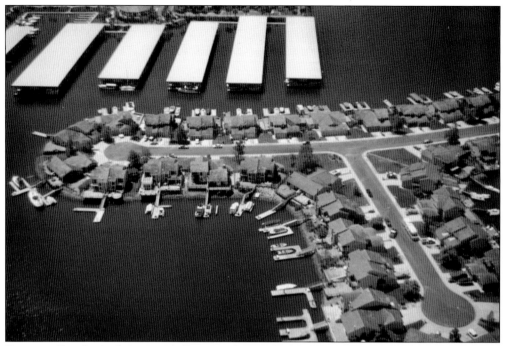

Discovery Bay, located just outside Byron in Contra Costa County, was one of the first to expand development to include a boat dock behind every home. This upscale suburban community has grown over the last 30 years. It embodies the new delta life.

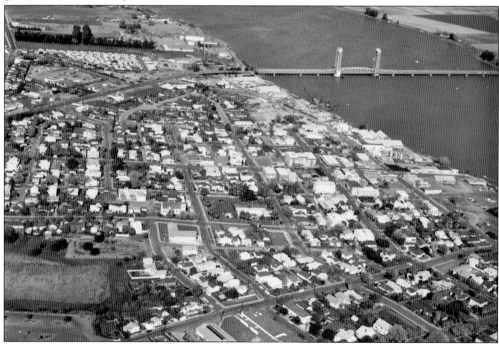

This aerial photograph shows the expansion and urbanization of Rio Vista. Housing pressures have led developers to plan grand designs in flood plains. County planning commissioners are approving construction below river level in areas that flood with regularity.

The bane of the California Aqueduct pumps is the mitten crab. This non-indigenous crustacean stole into California from Asia, probably in the hold of a ship. It loves the warm water and breeds like no one can believe. It clogs the pumps and does its best to thwart every effort to eliminate it.

The beautiful water hyacinth, introduced from Africa, does its best to choke the delta waters. This houseboat is surrounded. The plant endangers fish by removing oxygen from the water. A way of eliminating it has yet to be discovered.

When they are open, these gates in the man-made Delta Cross Channel, located near Locke and Walnut Grove, permit Sacramento River water to flow into the central delta's San Joaquin River system. Note the low-level clearance for limited boat access. There is no drawbridge here.

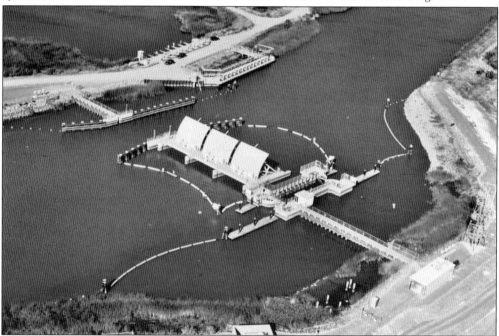

The Montezuma Slough salinity gates regulate the amount of freshwater entering the slough from the Sacramento River system. The delta is not naturally a freshwater system. It is affected by the tides, and salinity levels vary both naturally and artificially thorough man-made barriers like this one.

Wakeboarding and wakesurfing are now all the rage along the water. Waterskiing is considered "old school." In Discovery Bay, there is even a little terrier named Chewy, owned by Rex and Debbie Fair, who wakeboards. He is the "spokesdog" for a line of wake equipment.

Today vacationers are just as likely to arrive in a recreational vehicle as in a houseboat. The 1,000 miles of waterways are paralleled by 1,000 miles of roadways. State and county parks provide full hookups for motor coaches, trailers, and campers.

Hal Schell wrote five books and several thousand articles and columns about the California Delta. He rode on the steamboat *Eppleton Hall*, was on the last voyage of the *Delta King*, and traveled overnight to the Port of Stockton from San Francisco on a foreign freighter with bar pilot Bob Attowe. He will be missed.

SELECTED READING

baydeltaoffice.water.ca.gov (California Department of Water Resources, Bay-Delta)

California Department of Water Resources. *Sacramento San Joaquin Delta Atlas*. Sacramento, CA: California Department of Water Resources, 1993.

Schell, Hal. All about Camping in Europe. Mill Valley, CA: Ed Buryn Books, 1970.

———. Cruising California's Delta. Stockton, CA: Shell Books, 1995.

———. Dawdling on the Delta: The Complete Cruising Guide for California's Fabulous 1,000-Mile Delta. Stockton, CA: Shell Books, 1983.

———. Delta Images No. 1: Picture Tour of the 1,000-Mile Delta. Stockton, CA: Shell Books, 1982.

———. Hal Schell's Guide to Cruising and Houseboating the Delta: California's 1,000-Mile Inland Waterway. Stockton, CA: Shell Books, 1979.

www.californiadelta.org (California Delta Chambers and Visitors Bureau)

www.cocohistory.com (Contra Costa County Historical Society)

www.deltawetlands.com (The Delta Wetlands Project)

www.isletonhistory.org (Isleton Brannan-Andrus Historical Society)

www.johnmarshhouse.com (John Marsh Historic Trust)

www.riovista.org (Rio Vista Chamber of Commerce)

www.sacdelta.com (Sacramento-San Joaquin Delta, California)

www.theschoolbell.com (East Contra Costa Historical Society and Museum)

ACROSS AMERICA, PEOPLE ARE DISCOVERING SOMETHING WONDERFUL. *THEIR HERITAGE.*

Arcadia Publishing is the leading local history publisher in the United States. With more than 3,000 titles in print and hundreds of new titles released every year, Arcadia has extensive specialized experience chronicling the history of communities and celebrating America's hidden stories, bringing to life the people, places, and events from the past. To discover the history of other communities across the nation, please visit:

www.arcadiapublishing.com

Customized search tools allow you to find regional history books about the town where you grew up, the cities where your friends and family live, the town where your parents met, or even that retirement spot you've been dreaming about.